Companion to

Spanish Colonial Art
at the Denver Art Museum

Donna Pierce

© 2011 Denver Art Museum
Published by the Mayer Center for Pre-Columbian &
Spanish Colonial Art at the Denver Art Museum

Denver Art Museum.
 Companion to Spanish colonial art at the Denver Art Museum / Donna Pierce.
 p. cm.
 Includes bibliographical references.
 ISBN 978-0-914738-78-7
 1. Art, Spanish colonial--Latin America--Catalogs. 2. Art--Colorado--Denver--
Catalogs. 3. Denver Art Museum--Catalogs. l. Pierce, Donna, 1950- ll. Frederick and
Jan Mayer Center for Pre-Columbian and Spanish Colonial Art. lll. Title.
 N6502.2.D46 2011
 709.8'07478883--dc23
 2011044286

Mayer Center for Pre-Columbian & Spanish Colonial Art
Denver Art Museum
100 West 14th Avenue Parkway
Denver, CO 80204
http://mayercenter.denverartmuseum.org
www.denverartmuseum.org

Editor: Laura Caruso
Captions research and compilation: Julie Wilson Frick
Photography: Jeff Wells (unless otherwise noted)
Project coordination, design, and production: Julie Wilson Frick

Front cover and inside back cover: (detail) Fig. 22.
Page 5: (detail) Fig. 26.
Distributed to the trade by the University of Oklahoma Press
Printed and bound by Johnson Printing
Published in the United States of America

Dimensions are listed in the following order:
Height x Width x Depth or Diameter.

**All objects pictured within are part of the Denver Art Museum
collection, unless otherwise noted.**

*With thanks to
the "angels,"
past and present,
who have helped the
collection grow.*

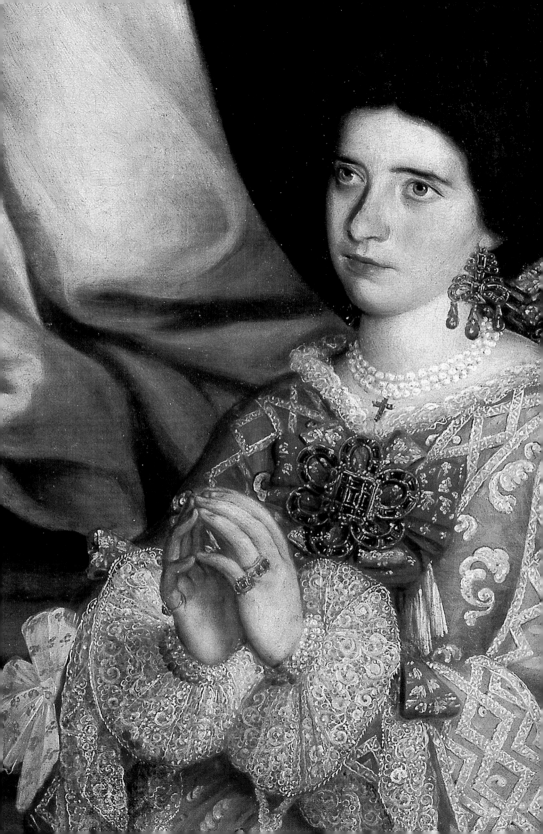

Foreword

The Denver Art Museum is indeed fortunate in being able to count among its greatest resources a Spanish Colonial collection rich in art from all over Latin America. Although the museum's Spanish Colonial collection began with Anne Evans's 1936 gift of a group of *santos* from southern Colorado and northern New Mexico, its true genesis should probably be credited to Otto Karl Bach, who began his successful thirty-year tenure as the museum's director in 1944. Ignoring the advice of eastern colleagues to carve out a special niche in regional art, Bach boldly set out to build an encyclopedic collection of world art and make it available to the people of Denver and the Rocky Mountain region. In 1952, the museum made its first purchase of Pre-Columbian art and in 1968, Bach established a New World Department that brought Pre-Columbian and Spanish Colonial objects from the Americas together under the curatorship of Robert Stroessner. Today the combined collection of the New World Department covers a time span from circa 1200 BC to the present. It is the best collection of its type in the United States and, in many areas, it is the most comprehensive collection outside of country of origin.

The New World Department as a whole has benefited greatly from the unwavering support of longtime museum trustee Frederick Mayer and his wife Jan. They collaborated with Stroessner and later curators to further build the collections and to develop related programming. In 1993, under the aegis of then-director Lewis Sharp, the New World Department collections were reorganized and reinstalled in their present galleries, which made Denver, at the time, the only major museum in the country to have permanent galleries dedicated to both Pre-Columbian and Spanish Colonial art. Over 5,000 objects from these collections are displayed in the Jan and Frederick Mayer Galleries

of Pre-Columbian and Spanish Colonial Art. Included are paintings, sculpture, furniture, silver, and decorative arts from the Spanish Colonial period as well as Pre-Columbian masterworks of ceramic, stone, gold, and jade. These two collections are remarkable for both aesthetic quality and cultural significance. Internationally, the Denver Art Museum is unparalleled in its comprehensive representation of the major stylistic movements from all the geographic areas and cultures of Latin America.

The growth of the New World collections and programs received a major boost with the enlightened endowment gift of Frederick and Jan Mayer. This gift made it possible to establish separate curatorial positions in Pre-Columbian and Spanish Colonial art. As a result of the Mayers' generosity, the Denver Art Museum has the only curator devoted exclusively to Spanish Colonial art in the United States. The Mayers also founded the Frederick and Jan Mayer Center for Pre-Columbian and Spanish Colonial Art at the Denver Art Museum, dedicated to increasing awareness and promoting scholarship in these fields by sponsoring scholarly activities including annual symposia, fellowships, study trips, and publications, including this volume.

Over the years, the Mayers generously supported the museum's larger mission in many ways. Since his death in 2007, Frederick Mayer's energy and spirit have been greatly missed. We are blessed to have the ongoing support of Jan Mayer and offer warm thanks to her for her continuing commitment to the museum as a whole.

Christoph Heinrich
Frederick and Jan Mayer Director, Denver Art Museum

Acknowledgments

Initiated in 1936 with a gift from Anne Evans of *santos* from Colorado and New Mexico, the Spanish Colonial collection at the Denver Art Museum grew dramatically under the enlightened curatorship of Robert Stroessner from 1968 to 1991. With the support of Frederick and Jan Mayer, Stroessner cultivated collectors nationally as well as in the Denver area.

Within a year of its founding in 1968, the New World Department began receiving the Frank Barrows Freyer Memorial Collection of colonial paintings, sculpture, and furniture from Peru. Assembled by María Engracia Freyer during the 1920s while her husband was chief of a U.S. naval mission to Peru, the collection received special export status in recognition of Mr. Freyer's contributions to the reorganization of the Peruvian navy and Mrs. Freyer's efforts on behalf of education and public welfare in Peru. In 1990, the Stapleton Foundation of Latin American Colonial Art gifted its collection of colonial art from northern South America acquired between 1895 and 1914 by Daniel C. Stapleton, a donation made possible by the Renchard family of Washington, D.C. In addition, an exemplary collection of Spanish colonial silver from the Robert Appleman family and major gifts of Mexican colonial painting and decorative arts from the collection of Frederick and Jan Mayer have greatly enriched the collection. Other important contributions over the years came from Belinda Straight, Ramón Osuna, James Economos, Morris A. and Von Long, Lorraine and Harley Higbie, Horace and Jane Day, Marilynn and Carl Thoma, Susan and Dick Kirk, Carl Patterson, Edward and Hope Connors, and Alianza de las Artes Americanas, the New World Department's support group.

During planning meetings for the Mayer's generous endowment to the New World Department, Jan Mayer

enthusiastically expressed her desire for introductory publications on Pre-Columbian and Spanish Colonial art illustrated with the museum's collections. The former was published in 2003; the latter is issued here and serves as one of the first in a new series of guides to the collections at the Denver Art Museum, begun under the spirited leadership of Director Christoph Heinrich.

All New World staff members are involved in our publications. I gratefully acknowledge the contributions and encouragement of Margaret Young-Sánchez, Frederick and Jan Mayer Curator of Pre-Columbian Art; Patricia Tomlinson, Curatorial Assistant; Michael Brown, Mayer Center Fellow; Anne Tennant, Research Associate; Jana Gottshalk, Research Intern; and Julie Wilson Frick, Mayer Center Program Coordinator. As part of her role in the department, Julie Wilson Frick compiles, designs, and manages all of our publications; she is responsible for the beautiful design and layout of this volume. She also authored the captions. Museum photographer Jeff Wells, along with John Lupe and Juhl Wojahn and their respective staffs, have worked with us patiently to complete the preparations for this book. Laura Caruso has contributed her editorial magic and Fabrice Weexsteen his mapmaking expertise. For many years of research collaboration, I thank my colleagues Julie Wilson Frick, Michael Brown, and former Director of Conservation Carl Patterson.

I know I speak on behalf of all of us when I say that we are immeasurably grateful to Jan and the late Frederick Mayer for their years of support and friendship. This book is for them.

Donna Pierce
Frederick & Jan Mayer Curator of Spanish Colonial Art/
Head of the New World Department, Denver Art Museum

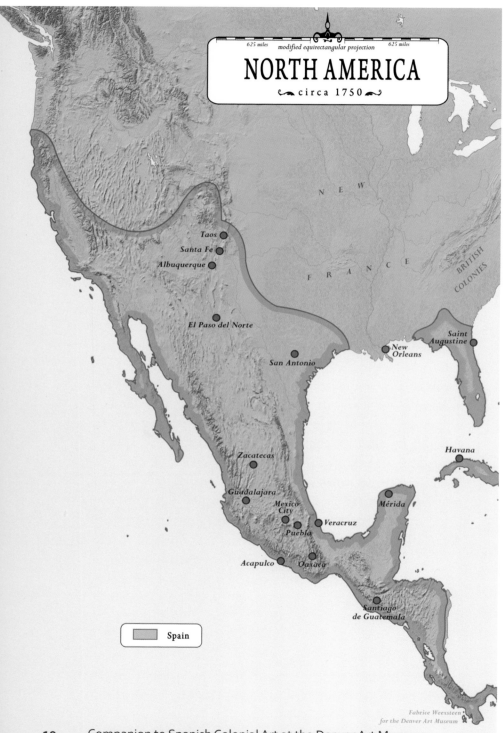

625 miles modified equirectangular projection 625 miles

NORTH AMERICA

circa 1750

N E W

F R A N C E

BRITISH
COLONIES

Taos

Santa Fe

Albuquerque

El Paso del Norte

*New
Orleans*

*Saint
Augustine*

San Antonio

Havana

Zacatecas

Guadalajara

*Mexico
City*

Mérida

Puebla

Veracruz

Acapulco

Oaxaca

*Santiago
de Guatemala*

Spain

Fabrice Weexsteen
for the Denver Art Museum

Companion to Spanish Colonial Art at the Denver Art Museum

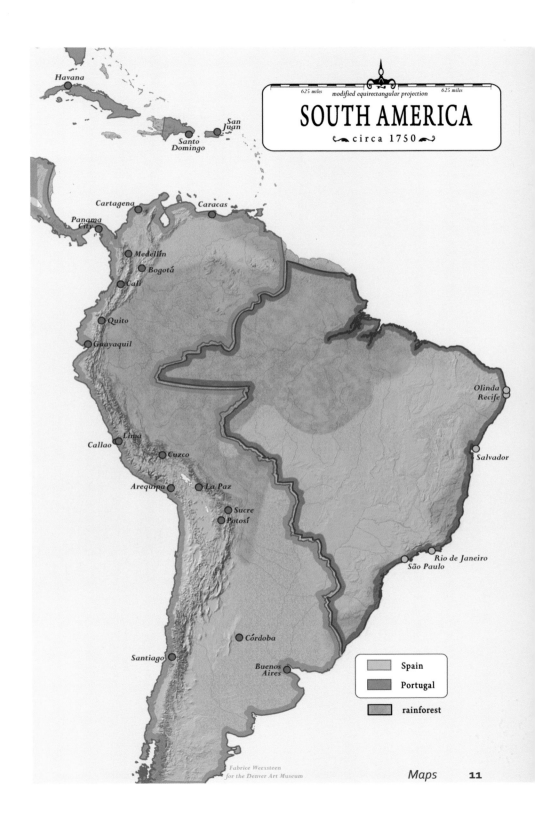

Havana

San Juan

Santo Domingo

Cartagena Caracas

Panama City

Medellín

Bogotá

Cali

Quito

Guayaquil

Olinda
Recife

Lima

Callao

Cuzco

Salvador

Arequipa La Paz

Sucre
Potosí

Rio de Janeiro
São Paulo

Córdoba

Santiago

Buenos Aires

625 miles *modified equirectangular projection* 625 miles

SOUTH AMERICA

circa 1750

	Spain
	Portugal
	rainforest

Fabrice Weexsteen
for the Denver Art Museum

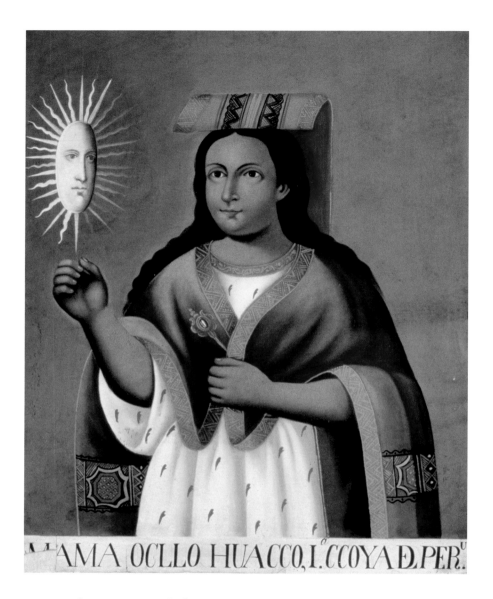

AMA OCLLO HUACCO, I.ᵒ CCOYA Đ.PERᵘ.

Fig. 1. *Mama Occllo* from *Inca Rulers* (set of sixteen, detail). Peru, late 1800s. Oil on canvas. 25¹/₂ x 19¹/₂ in. Gift of Dr. Belinda Straight; 1977.45.

Columbus's encounter with the Americas and Magellan's circumnavigation of the world marked the beginning of the modern era of global trade. For the first time in history, the entire world was in contact. Although Columbus never found the trade route to Asia he was seeking, Spain finally opened one in 1565 after occupying the Philippines. Large galleon ships began to sail from Manila to Acapulco loaded with luxury goods from all over Asia. Silks, spices, and fragile porcelains were offloaded and carried overland by mule to Mexico City or to the coast for shipment across the Atlantic to Spain or to other areas of Latin America. Mexico—with its own sophisticated ancient tradition of art—sat at the crossroads where Asian objects traversed the Pacific, European goods came over the Atlantic, and American products were exported in return. Objects from all these areas came together in colonial Latin America, inspiring local artists to alter and mingle details in new ways (see maps, pp. 10–11).

Fig. 2. Detail of Fig. 6.

The Spanish Colonial period (1521–1830s) in Latin America is roughly contemporary with the era of the British colonies in the continental United States, although it began nearly a hundred years earlier and lasted some fifty years longer. During the era of

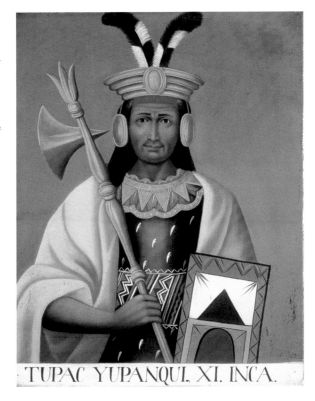

Fig. 3. *Tupac Yupanqui* from *Inca Rulers* (set of sixteen, detail). Peru, late 1800s. Oil on canvas. 25$^{1}/_{2}$ x 19$^{1}/_{2}$ in. Gift of Dr. Belinda Straight; 1977.45.

TUPAC YUPANQUI, XI. INCA.

exploration and conquest in the 1500s, Spanish adventurers conquered the Aztec empire in Mexico in 1521 (fig. 2) and the Inca in Peru in the 1530s (figs. 1, 3). Immediately afterward, Spanish governors, settlers, and missionaries began immigrating to these colonies. By 1598, the Spanish empire in the Americas spread from southern Colorado to the southern tip of South America (excluding Brazil). The resulting culture and art is a combination of European and indigenous traditions, with some inspiration from Asia as well. Although the overall impression of Spanish Colonial style often appears overwhelmingly European, art was often made by native artists and

eventually by artists of all ethnic backgrounds born in the Americas. As a result, subtle evidence of the New World sensibilities of these artists is usually present.

Europeans were intrigued by the sophistication of the arts of the Americas (pp. 22–25). When Aztec artworks were exhibited in Spain and Brussels in 1520, the German artist Albrecht Dürer wrote:

> *In all my life I have never seen*
> *anything that has so delighted*
> *my heart as did these objects; for*
> *I saw strange works of art and*
> *have been left amazed by the subtle*
> *inventiveness of the men of far-off*
> *lands.*

In addition, European chroniclers of the early colonial period commented on the facility with which native artists learned European artistic techniques. According to a missionary friar in Mexico known as Motolinía,

> *In the mechanical arts the Indians*
> *have made great progress, both*
> *in those which they cultivated*
> *previously and in those they learned*
> *from the Spaniards. After the*
> *arrival of Flemish and Italian*
> *models and paintings which the*
> *Spaniards brought, excellent artists*
> *developed among the Indians.*

Continuity of Native Traditions

Many indigenous art forms continued during the Spanish Colonial era and were adapted to European and Christian subject matter. The tradition of feather arts—previously used for making elegant Aztec feather capes, shields, and images of native gods—was now used to create shimmering pictures of Christian saints that became collectors' items in Europe (fig. 5; pp. 22–25). The Mexican tradition of creating lightweight, corn-pith paste sculptures, a technique similar to papier-mâché, was now applied to large statues of Christ on the Cross (fig. 4). Easier to carry in processions than heavy wooden sculptures, they soon became popular in Europe. The native manner of producing hand-painted books, maps, and genealogies, perfected in the Mixtec region of southern Mexico, was continued in monastery schools and survived to the present in genealogies and land claim documents (fig. 6). In Peru, the Inca produced and drank *chincha*, a fermented beverage made from corn, for ceremonial occasions. Special wooden cups painted with colorful designs were made for drinking *chincha* in Inca times and continued to be made throughout the colonial era (fig. 7).

In Colombia, the ancient tradition of using the gum of the *mopa mopa* bush to decorate wooden objects was continued throughout the colonial period. Now known as *barniz de pasto* after the town of

Fig. 4. Crucifix. Guanajuato, Mexico, circa 1700. *Caña de maíz* technique (celerin wood [*tzompantle*], corn paste, gesso, fabric, oil paint). 47 x 40 in. Museum exchange; 1968.192.

Colombia

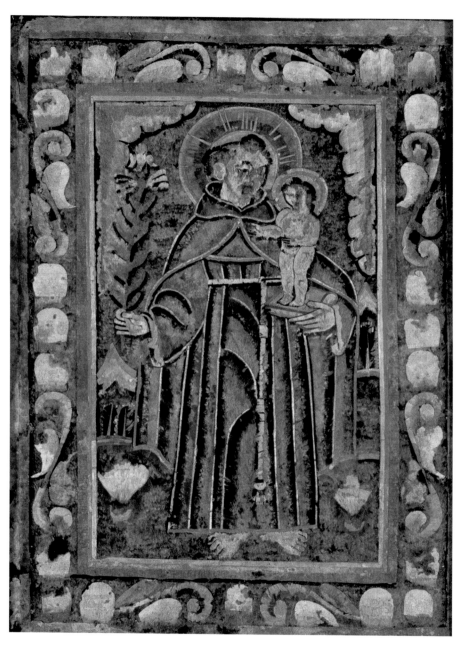

Fig. 5. *Saint Anthony.* Mexico, 1600s. Feathers, paper, copper.
11¹/₈ x 8 in. Collection of Frederick & Jan Mayer; 19.1993.

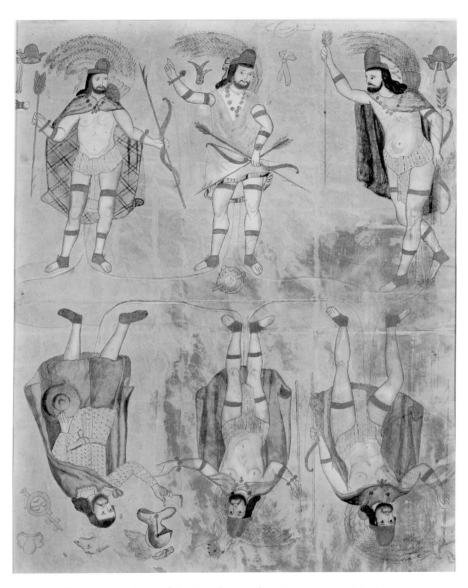

Fig. 6. *Genealogy of the Family Mendoza/Moctezuma*. Mexico, 1856–57. Watercolor on paper. 17 x 12³/₈ in. Bequest of Robert J. Stroessner; 1992.68.

Pasto in southern Colombia, one of the centers of production, the technique includes chewing the gum, embedding it with pigments, and stretching it over portions of wooden objects (fig. 8). Sometimes it is underlaid with thin sheets of silver to create a translucent sheen unique to these objects. In the Michoacán and Guerrero areas of western Mexico, a native technique for decorating wooden objects that continued through the colonial era was *laca*, or lacquerware, which employs shellac made from the *aje*, an insect native to the area. Examples from the Michoacán area demonstrate the influence of Asian lacquerware imported by means of the Manila galleon trade route.

Another technique that may be related to both Pre-Hispanic shell mosaic and Asian shell inlay traditions was invented in colonial Mexico. *Enconchado* (shell inlaid) panels and objects were inset with pieces of mother-of-pearl and then painted with thin layers of oil paints to create a new form of art unique to colonial Mexico (figs. 9, 10).

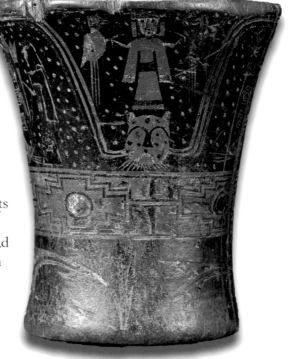

Fig. 7. Cup *(Kero)*. Peru, circa 1600. Lacquer on wood. 8 x 6³/₄ in. Bequest from the Estate of Leon H. Snyder; 1978.288.

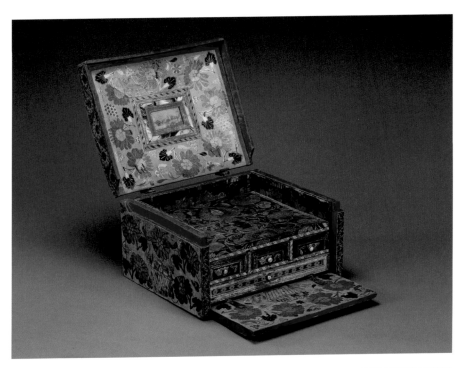

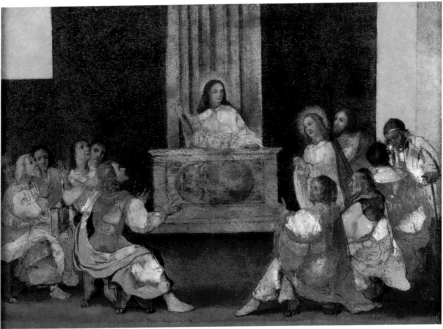

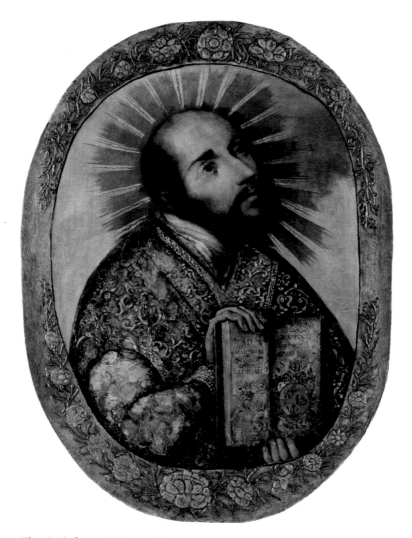

Fig. 8. (left, top) Chest. Colombia, 1700s. Polychromed wood, *barniz de pasto*, silver leaf, glass, bone. 7¹/₂ x 13¹/₂ x 11¹/₂ in. Gift of the Stapleton Foundation of Latin American Colonial Art, made possible by the Renchard Family; S-25.

Fig. 9. (left, bottom) *Christ Teaching in the Temple*. Mexico, late 1600s. Oil on wood panel, shell inlay. 11¹/₄ x 14¹/₂ in. Anonymous gift; 1991.1160.

Fig. 10. (above) Augustín del Pino, *Saint Ignatius Loyola*. Mexico, early 1700s. Oil on wood panel, shell inlay. 33¹/₂ x 23¹/₂ in. Collection of Frederick & Jan Mayer; 69.1998.

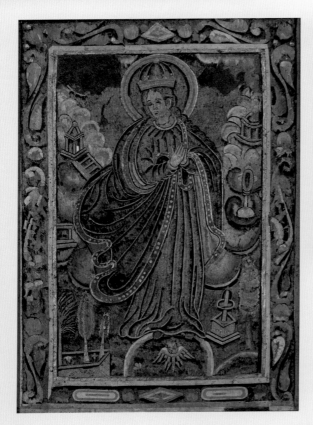

Immaculate Conception. Mexico, 1600s. Feathers, paper, copper. 11$^1/_2$ x 8$^5/_8$ in. Collection of Frederick & Jan Mayer; M2003.003.

When Spanish troops first entered the great city of the Aztecs, Mexico-Tenochtitlan—located on an island in the middle of a lake, traversed by canals like Venice, and connected to the mainland by broad paved causeways—they were fascinated. Bernal Díaz del Castillo, one of the captains in Cortés's small army of conquerors, described his first sight of the city in 1519:

> *We were amazed and said that it was like the enchantments they tell of in the legend of Amadis [de Gaul], on account of the great towers and pyramids and buildings rising from the water, and all built of masonry. And some of our soldiers even asked whether the things that we saw were not a dream.*

Among the strange and magnificent works of Aztec art that filled the early conquistadors with wonder were beautiful mosaics made from bird

feathers. Hernán Cortés himself expressed admiration for these indigenous works in a letter written to the King of Spain from Mexico in 1520:

> [Moctezuma has] all the things to be found under the heavens in [his] domain, fashioned in gold and silver and jewels and feathers...and those in feathers more wonderful than anything in wax or embroidery.

Cortés had shipments of magnificent treasures sent to Spain in which gold and featherwork formed the bulk of goods destined for churches, monasteries, and various dignitaries, as well as for the king himself.

During Aztec times, feather art was learned and practiced in imperial schools including the one attached to Moctezuma's royal aviary where birds from all over Mexico and Guatemala were bred and raised to provide a constant feather supply. Upon visiting the royal aviary, Díaz del Castillo felt

> forced to abstain from enumerating every kind of bird that was there and its peculiarity, for there was everything from the Royal Eagle...down to tiny birds of many-colored plumage.

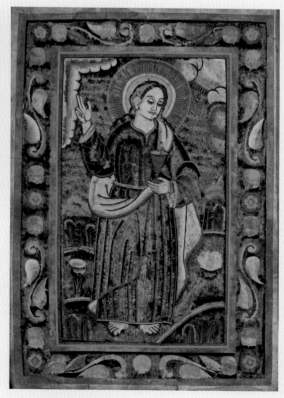

Saint John the Evangelist. Mexico, 1600s. Feathers, paper, copper. 15 x 11¼ in. Collection of Frederick & Jan Mayer; M1995.22. Photograph © James Milmoe.

Left and right: Photographs of the same object taken from different angles by Jeff Wells, Denver Art Museum. Juan Bautista, *Jesus at the Age of Twelve*. MIchoacán, Mexico, 1590–1600. Feathers, copper. 10 x 7⅛ in. Kunsthistorisches Museum, Vienna.

Among the feathers used were those of the quetzal, hummingbird, parrot, heron, spoonbill, troupial, and blue cotinga.

Two techniques were employed in Aztec featherwork. For feather clothing, headdresses, and fans, the feathers were sewn with maguey thread in an overlapping pattern onto net fabric or cane frameworks. For feather mosaic pictures or shields, patterns were drawn on native paper, and then feathers, cut to size with copper or obsidian blades, were applied with bone tools. Fine lines were created by overlapping the layers so closely that some colors almost disappeared, and the contrast between iridescent and matte feathers was manipulated to create various effects.

Although the Spaniards destroyed native pyramids, temples, and images of deities, they encouraged the continuation of many indigenous art forms—only now devoted to Christian iconography. They founded schools attached to missions and monasteries where Indian artists made Aztec-style feather mosaics depicting saints rather than pagan gods.

Particularly renowned were the mission schools of Mexico City and Michoacán in western Mexico. Not only was feather art used for pictures of saints, but also to produce liturgical garments, particularly bishops' miters. These featherworks were often based on European prints and made for use in local churches and convents as well as for export to Europe, where they were collected as curiosities and displayed in wonder cabinets.

Featherworks were particularly prized by Spanish Christians, who considered the iridescence of the featherworks, and their ability to seemingly change color, to represent divine light from heaven. Bartolomé de Las Casas, a Spanish missionary in early colonial Mexico, praised the skill of the artists in placing a feather so that

> looked at from one angle, it will seem golden while lacking gold; from another angle, it will have a green sheen without being green; looked at crosswise, it will display another lovely color; and the same from many other angles, all shimmering marvelously. ❧

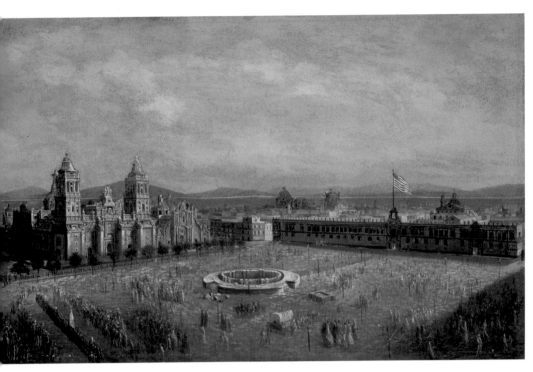

Fig. 11. Pedro Antonio Gualdi, *Plaza of Mexico City* (Cathedral on left; National Palace on right). Mexico, 1847. Oil and gouache on paper. 9$\frac{1}{2}$ x 14$\frac{1}{2}$ in. Gift of Mrs. Frederic H. Douglas; 1956.72.

Fig. 12. (right) Mission church exterior. Huejotzingo, Mexico, 1541–70. Photograph by D. Pierce.

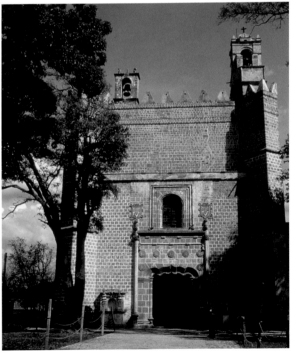

Art for Churches and Missions

As part of the colonization effort, Spaniards founded towns with cathedrals and civic buildings (fig. 11) and established mission churches and schools in Indian settlements (figs. 12–13). Fresh from their long war to reconquer Spain from Muslim control (completed in 1492), Spaniards, unlike their British and French contemporaries, considered Christianization of Indians in the Americas as a priority. Hundreds of churches were constructed within the first few decades of colonization. Churches were decorated with stone carvings on the exterior (figs. 11–14) and, initially, with mural paintings on the interior (fig. 15), traditions common to both European and native American cultures. Usually churches were constructed of cut stone, but in some areas—most notably in New Mexico on the far northern frontier of the Spanish territories and some highland areas of Peru and Bolivia—adobe was used instead (figs. 16–17). A tradition common to both the Americas and southern Europe, adobe structures were made from bricks of sun-dried mud.

By the late 1500s, large altarscreens—created from architectural components of carved wood covered with gold leaf and paint

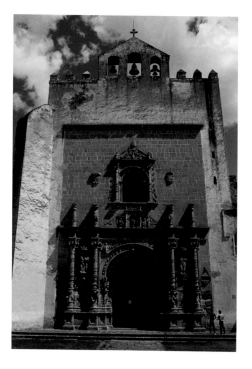

Fig. 13. Mission church exterior. Acolman, Mexico, begun 1550. Photograph by D. Pierce.

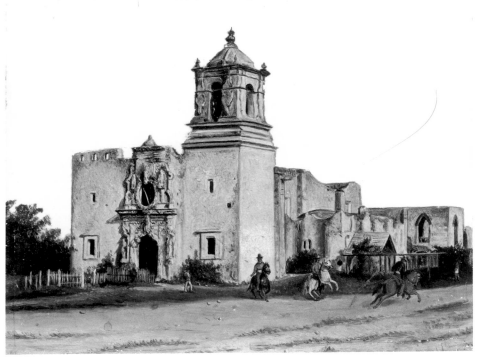

Fig. 14. *Mission of San José & San Miguel de Aguayo (1768–82).* San Antonio, Texas, 1800–1850. Oil on panel. 8 x 10 in. Gift of Robert J. Stroessner; 1991.1138.

Fig. 15. Mission church interior. Acolman, Mexico, begun 1550. Photo by D. Pierce.

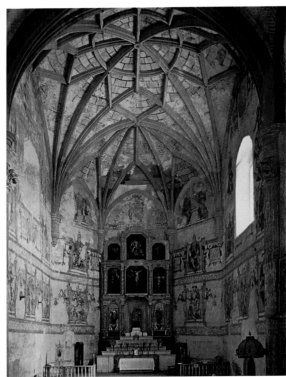

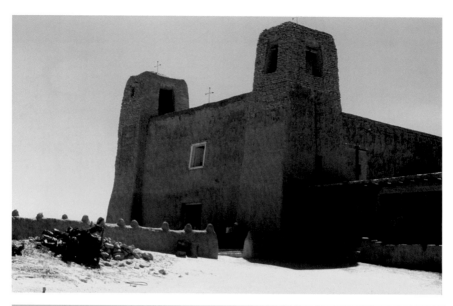

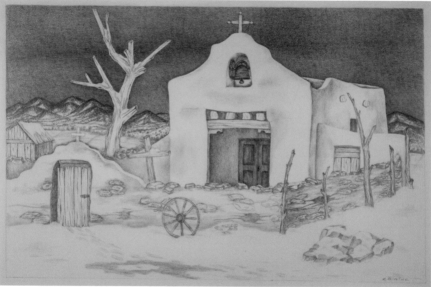

Fig. 16. Church exterior. Acoma, New Mexico, begun 1641. Photo by D. Pierce.

Fig. 17. Mary Valentine, *Drawing of Durán Chapel (1830–1850)*. Talpa, New Mexico, early 1900s. Charcoal pencil on paper. 18 x 22¹/₂ in. Anne Linde Memorial Fund; 1972.74.

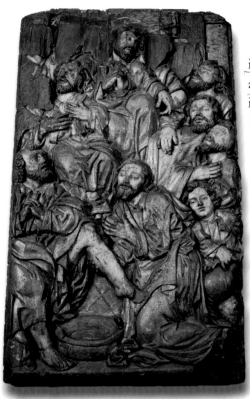

Fig. 18. *Christ Washing the Feet of the Apostles*. Mexico, circa 1600. Paint, gold, wood. 54 x 30 in. Gift of Mr. & Mrs. Morris A. Long; 1986.603.

interspersed with paintings and sculpture—began to be installed in churches (fig. 15). Designed and overseen by emigrant European artists, the early altarscreens were executed in the Renaissance style (fig. 18), and native artists were trained and employed in their manufacture.

As in Europe, the relief carvings and statues in the altar screens of Latin America were carved of wood (fig. 19, pp. 36–37). Fabric areas of statues were treated with a technique known in Spanish as *estofado*, in which the wood was covered with a gesso mixed with a brownish-red pigment called *bole*. Tissue-thin sheets of hammered gold were then applied to the *bole* ground. Next, paint was applied over the gold leaf. The paint layer was then stamped or etched through to reveal the gold leaf underneath, in imitation of the elaborate brocade fabrics of the period. Areas depicting skin, such as the faces and hands, were created using a different technique of manufacture known as *encarnación*, in which the carved wood was covered with a white gesso that was then painted in flesh tones. A layer of shellac was applied over the paint and gently

sanded or burnished. Next another thin layer of flesh-colored paint was applied, shellacked, and burnished. The process was repeated until the buildup of layers achieved a glowing surface imitating real skin.

Artists such as Luis Lagarto and Sebastián López de Arteaga from Seville, Spain (figs. 20, 22), Alonso López de Herrera from Valladolid, Spain (fig. 21), and Simon Pereyns and Diego de Borgraf (fig. 23) from Flanders emigrated from Europe to assist in the decoration of churches and government buildings. Often the European artists needed Indian assistants to accomplish their work. Although artist guilds founded in the colonial period prohibited Indian artists from being members, it is clear that much of the work, particularly for the missions, was executed by native artists. In some cases, native artists were commissioned to execute altarscreens; for example, Miguel Mauricio, who made the one for the mission church at Tlatelolco, Mexico.

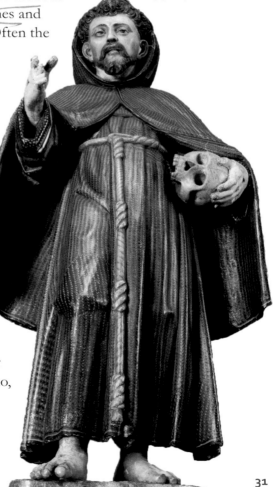

Fig. 19. *Saint Francis of Assisi.* Puebla, Mexico, circa 1650. Paint, gold, wood. 47 x 22 x 15 in. Gift of Robert J. Stroessner; 1992.27.

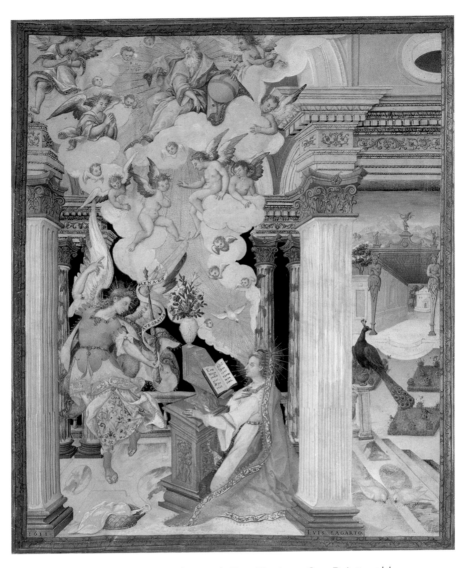

Fig. 20. Luis Lagarto, *Annunciation*. Mexico, 1611. Paint, gold, parchment. 12³/₈ x 9³/₄ in. Collection of Frederick & Jan Mayer; 18.1993.

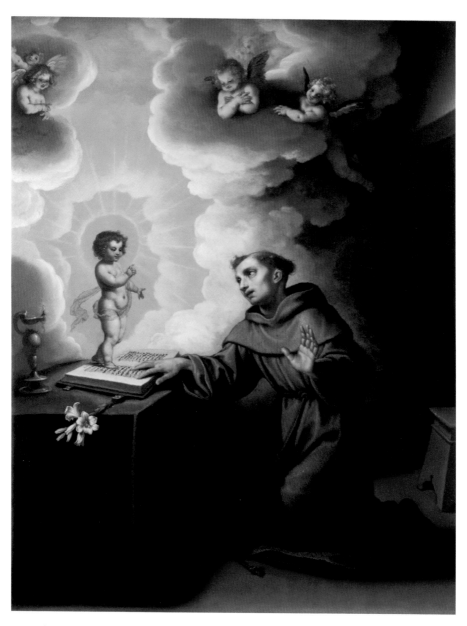

Fig. 21. Alonso López de Herrera, *Saint Anthony and the Christ Child*. Mexico, circa 1640. Oil on copper. 22¹⁄₄ x 16 in. Collection of Frederick & Jan Mayer; 22.1993.

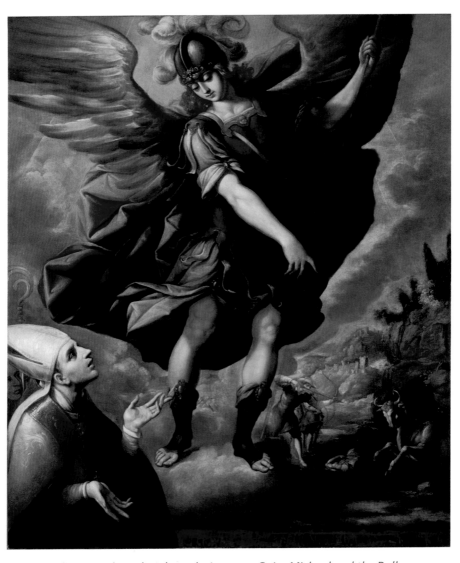

Fig. 22. Sebastián López de Arteaga, *Saint Michael and the Bull.* Mexico, circa 1650. Oil on canvas. 75 x 61 in. Gift of Frank Barrows Freyer II for the Frank Barrows Freyer Collection by exchange and Gift of Frederick & Jan Mayer; 1994.27.

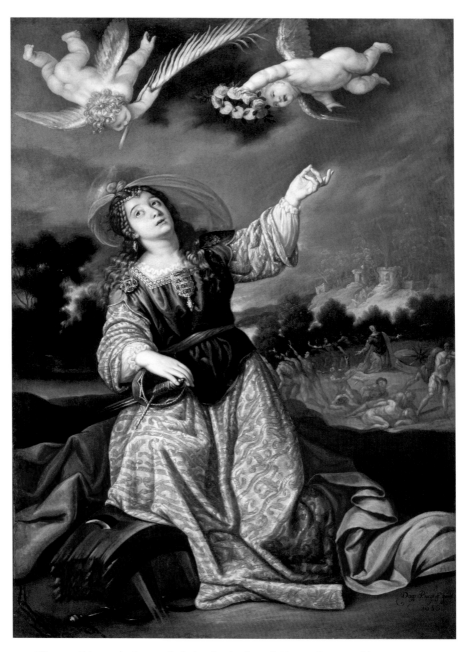

Fig. 23. Diego de Borgraf, *Saint Catherine of Alexandria*. Puebla, Mexico, 1656. Oil on canvas. 65³/₄ x 45³/₄ in. Collection of Frederick & Jan Mayer; 123.1982.

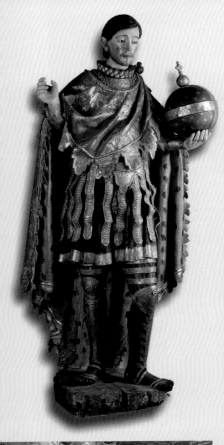

This statue of Saint Ferdinand, the King of Castile and León in Spain, was originally part of an altarscreen installed in the Cathedral of Querétaro, Mexico, around 1750. Many cathedrals in Spain and Latin America installed main altar pieces dedicated to royal saints. Known as Altars of the Kings, they included statues of members of European royalty who became saints and incorporated paintings of the Adoration of the Kings at the Nativity of Christ. In the screens, statues of Saint Ferdinand were often paired with ones of his cousin and friend, Louis IX of France. Examples in the cities of Puebla and Mexico City *(opposite, top)* survive, but the one in Querétaro was dismantled in the 1800s. The Denver statue of Saint Ferdinand was collected in Querétaro in 1920; its matching statue of Saint Louis of France is in a private collection in Mexico City.

Ferdinand III was instrumental in the struggle to reclaim large areas of the Iberian peninsula from Muslim occupation. Born near Salamanca in 1199, he became king in 1217 at the age of eighteen. Known as a wise and just ruler, Ferdinand had grown up during a period of intense effort to reclaim Spain for the Christians and, as a young king, he continued the movement. He had reconquered most of Spain by 1248. He made peace with the only remaining Muslim ruler, the emir of the province of Granada. Two and a half centuries later, in 1492, Granada was reconquered by Ferdinand III's descendant

Top: *Saint Ferdinand.* Querétaro, Mexico, 1730–60. Paint, gold, gesso, wood. 76 × 35 × 18 in. Gift of Sam Houston in honor of Helen Bonfils; 1956.91.
Bottom: Detail of Saint Ferdinand's cape.

and namesake, Ferdinand of Aragón, and his wife, Isabella.

Ferdinand III died in 1252 and was canonized in 1671. Ferdinand's younger cousin, Louis IX of France (1214–70), also became a saint as a result of his crusades in the Holy Land. Louis gifted a small statue of the Virgin to Ferdinand. Such small statues were popularly known as "saddle Virgins" since they were small enough to carry on campaign. The small statue became known as the Virgin of the Kings in reference to both Ferdinand and Louis and still survives in a special chapel attached to the Cathedral of Seville *(below, right)*.

The statue of Saint Ferdinand was created using the traditional Spanish sculptural techniques known as *estofado (opposite, bottom),* for areas depicting fabric, and *encarnación,* for areas depicting skin. By the 1700s the Querétaro area had developed an exquisite and distinctive style of sculpture reflecting inspiration from the textile industry in the area. When the statue of Saint Ferdinand came into the museum collection in 1956, damage had occurred to some of the *estofado* areas of the clothing. The statue was carefully cleaned and the traditional technique of *estofado* was used to replace areas that had been damaged in order to restore Saint Ferdinand to his former glory. 🪷

Top: *Altar of the Kings.* Cathedral of Mexico, Mexico City, 1718–37. Photograph by D. Pierce.
Bottom: *Virgin of the Kings.* Cathedral of Seville, Spain, circa 1240. Photograph by D. Pierce.

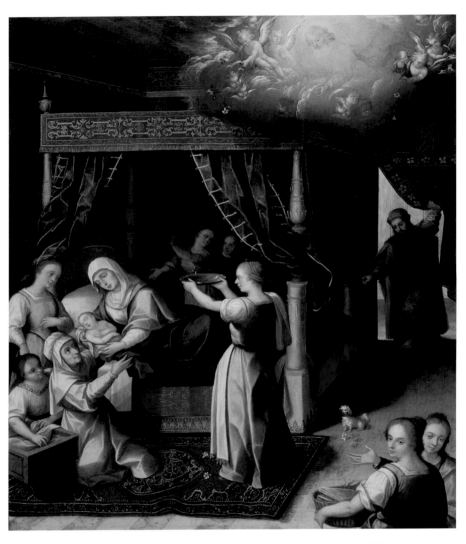

Fig. 24. Luis Juárez, *Birth of the Virgin*. Mexico, 1615–25. Oil on copper. 39¼ x 32¼ in. Collection of Frederick & Jan Mayer; 21.1993.

Artists of Spanish Colonial America

After the early surge of artists from Europe to Latin America, most artists in the 1600s and 1700s were born in the New World. Several of the early emigrant artists founded dynasties of painters that endured several centuries, such as Baltasar de Echave Orio, who immigrated to Mexico from the Basque region of Spain and whose descendants dominated painting in Mexico for many years; and Bernardo Bitti, an Italian missionary friar who immigrated to Peru in the mid-1500s, where he trained numerous native artists who continued his style into the next century.

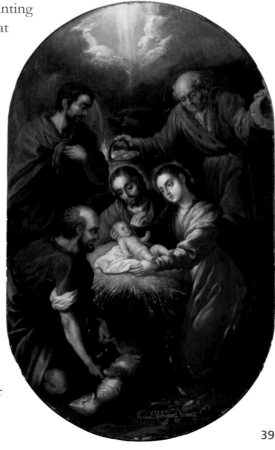

Fig. 25. Nicolás Rodríguez Juárez, *Adoration of the Shepherds*. Mexico, circa 1695. Oil, canvas, panel. 74 x 44 in. Gift of Frederick & Jan Mayer; 2009.763.

Luis Juárez started a painting workshop in Mexico that eventually included his son, his son-in-law, and both his grandsons (figs. 24–26). In Colombia, Gregorio Vásquez de Arce y Ceballos established a large workshop in Bogotá that included his older brother Juan Bautista and numerous assistants, and his style endured for many years (figs. 27–28).

Many Latin American artists were of European descent, but some were native or

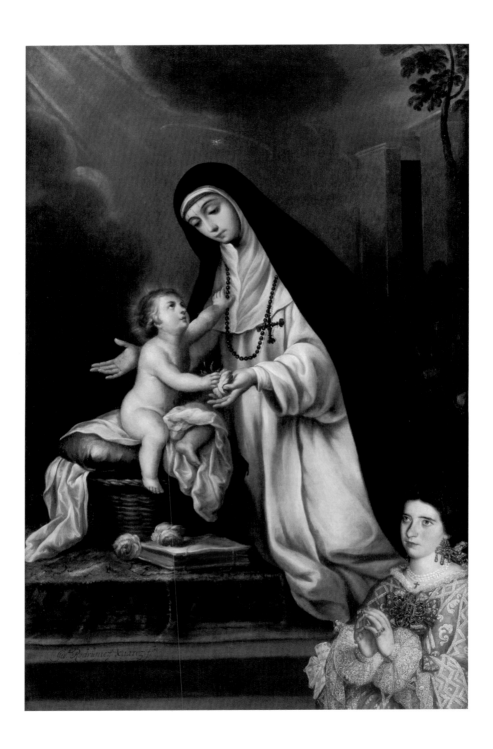

Companion to Spanish Colonial Art at the Denver Art Museum

of mixed ancestry. Two of the most famous painters of Mexico were of mixed blood: Miguel Cabrera was *mestizo* (half Indian, half Spanish) and Juan Correa was *mulatto* (half African, half Spanish) (figs. 29–30). Both operated large workshops where they trained numerous artists. The best known artist in Cuzco, Diego Quispe Tito, was an Indian of noble Inca ancestry (fig. 31), and the most famous artist in Bolivia in the 1700s, Luis Niño, was an Indian (pp. 46–47).

Fig. 26. (left) Juan Rodríguez Juárez, *Saint Rose of Lima with Christ Child and Donor.* Mexico, circa 1700. Oil on canvas. 66 x 42 in. Collection of Frederick & Jan Mayer; 145.2005.

Fig. 27. Juan Bautista Vásquez, *Virgin in Prayer.* Colombia, circa 1675. Oil on panel. $19^{1}/_{2}$ x $13^{5}/_{8}$ x $^{5}/_{8}$ in. Gift of the Stapleton Foundation of Latin American Colonial Art, made possible by the Renchard Family; S-478.

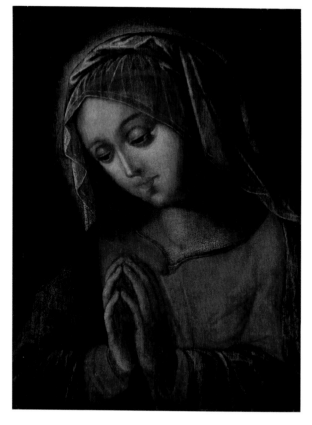

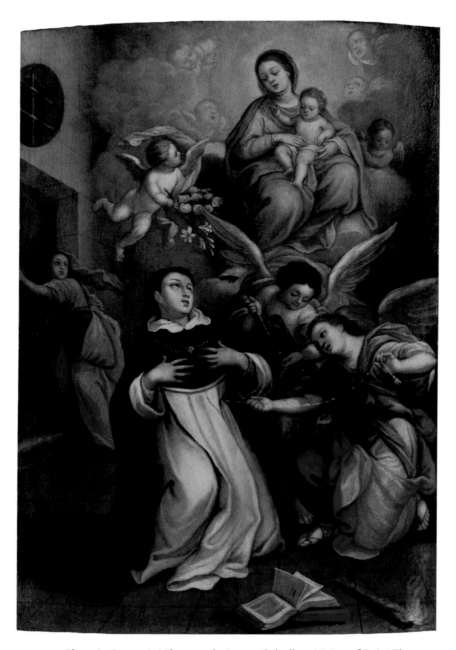

Fig. 28. Gregorio Vásquez de Arce y Ceballos, *Vision of Saint Thomas Aquinas*. Colombia, circa 1695. Oil on panel. 20³/₄ x 14¹/₂ in. Gift of the Stapleton Foundation of Latin American Colonial Art, made possible by the Renchard Family; S-133.

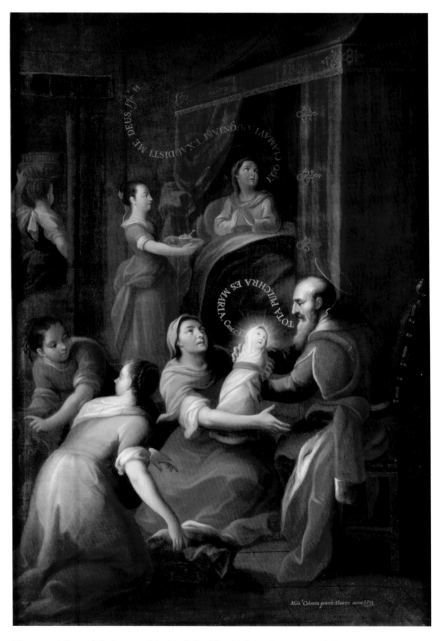

Fig. 29. Miguel Cabrera, *Birth of the Virgin*. Mexico, 1751. Oil on canvas. 72¹/₂ x 52³/₄ in. Collection of Frederick & Jan Mayer; 11.2005.

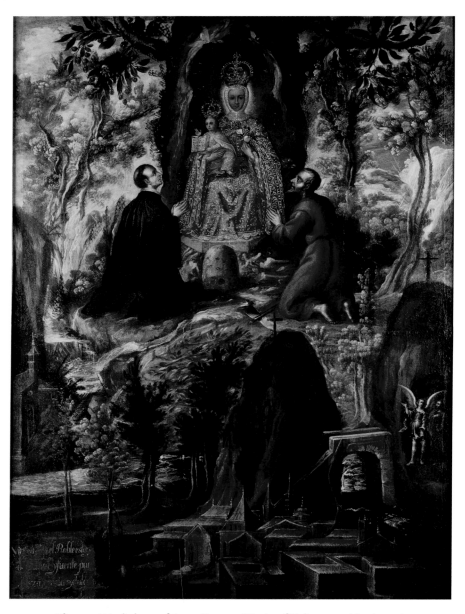

Fig. 30. Workshop of Juan Correa, *Virgin of Valvanera*. Mexico, circa 1700. Oil on canvas. 79^{1}/$_{2}$ x 57^{5}/$_{8}$ in. Gift of Frederick & Jan Mayer; 2008.832.

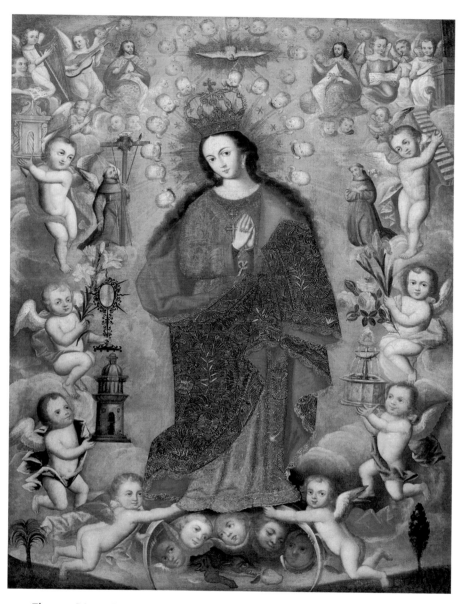

Fig. 31. Diego Quispe Tito, *Immaculate Conception with Franciscan Saints*. Cuzco, Peru, circa 1675. Oil on canvas. 64 x 48 in. Gift of Mr. & Mrs. John Critcher Freyer; 1969.344.

Luis Niño, *Our Lady of the Victory of Málaga*. Potosí, Bolivia, circa 1740. Oil on canvas. 59 x 44 in. Gift of John C. Freyer for the Frank Barrows Freyer Collection; 1969.345.

As indicated by the inscription along the bottom, this painting is a portrait of a famous sculpture of the Virgin from the city of Málaga in Spain. Immigrant Spaniards brought such devotions to the New World where they were altered in subtle ways to reflect local and native traditions.

This painting is attributed to an Indian artist named Luis Niño, who was born in Potosí, Bolivia. Niño was literate and was described as a painter, sculptor, and silverworker. He studied under the master painter Melchor Pérez Holguín and his works were exported to Europe, Lima, and Buenos Aires. His depiction of the Virgin of Málaga merges European and Indian artistic traditions and meanings in a unique and engaging work of art.

The original statue of the Virgin of Málaga is in Spain. It shows the seated Madonna with the Christ Child in her lap. When fashions changed,

this and similar images were dressed in luxurious fabric garments, making them appear to be standing rather than sitting. The garments were usually wide to cover the throne. Since Málaga is a port city, the Virgin is considered a patron of sailors, ships, and voyages.

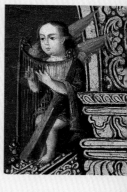

Although the painting was cut down, portions of scenes at the bottom show a miracle performed by the Virgin of Málaga in the New World *(opposite, details)*. She is in a cloud near the lower center of the painting. The top of the mast and sails of two ships appear at the bottom right corner of the painting. The flag with the red cross on one of the ships is the flag of Spain, used only in the New World. The scenes may depict a rescue from a pirate attack—a common occurence along the west coast of South America in the 1700s.

Although much of the painting's imagery derives from Spanish Catholic traditions, there are many distinctively Peruvian touches. The extraordinary use of gold decoration on the painting is exclusive to the highland areas of Peru and Bolivia. The two angels have red and blue wings, colors that were sacred to the Inca and symbols of nobility *(top, right)*.

Some aspects of the painting conflate meanings from both Spanish and Inca traditions. For example, the wide dress of the Virgin is similar to the actual wide cloth gowns used to dress statues of the Virgin in Spain. At the same time, it recalls the outline of the Inca mother goddess, Pachamama, who often appeared in the shape of a mountain, thereby endowing the Christian Virgin Mary with some of Pachamama's powers and traditions.

Knife (*Tumi*). Peru, 1500s. Copper alloy. $4^3/_4 \times 4^3/_4$ in. Bequest from the Estate of Leon H. Snyder; 1978.293.

The dark crescent moon at the feet of the Virgin symbolized the Christian belief in her immaculate conception. However, it is also reminiscent of the crescent-shaped *tumi* ceremonial knife of the Inca and pre-Inca cultures of Peru and Bolivia *(bottom)*. A symbol of victory and conquest, the *tumi* knife is often associated with the legendary first queen of the Inca, Mama Occllo, a fierce warrior herself (fig. 1). The insertion of its outline into a portrait of the Virgin transfers that power to her.

The crescent shape also refers to the Inca moon goddess and the halo around the Virgin's head recalls the Inca sun god. As a result the Inca pantheon is represented subtly within this image of the Virgin and Child. ❧

Hybrid Art Forms

By the mid-1600s, new styles of art had begun to develop in the Americas. Although based on the dominant European trends, often an entirely distinctive and unique style is discernible, sometimes including Asian influence. Incorporated into comprehensive and elaborate Baroque environments (fig. 32), some paintings on canvas became much larger in Mexico than they were in Europe. Elements from the local American environment such as landscape details, buildings, vegetation, fruits, and people were incorporated into the artwork. For example, tropical birds and flowers are a leitmotif of Andean colonial paintings (fig. 33). The importance of birds to Inca culture would have made the inclusion of images of feathers and wings particularly resonant in Peru. The Inca considered birds as sacred in part for their ability to fly and,

Fig. 32. (below) Church interior. Santa María Tonanzintla, circa 1700. Photograph by D. Pierce.

Fig. 33. (right, top) *Saint John the Evangelist*. Cuzco School, Peru, 1700s. Oil on canvas. 60 x 48 in. Gift of John C. Freyer for the Frank Barrows Freyer Collection; 1969.343.

Fig. 34. (right, bottom) Ignacio Chacón, *Madonna and Child with Bird*. Cuzco, Peru, circa 1765. Oil, gold, canvas. 25 x 18¹/₂ in. Gift of Engracia Freyer Dougherty; 1972.390.

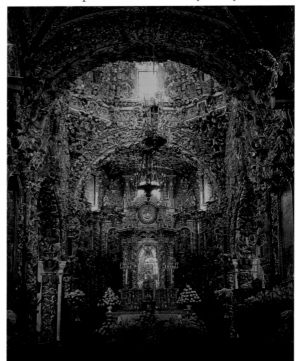

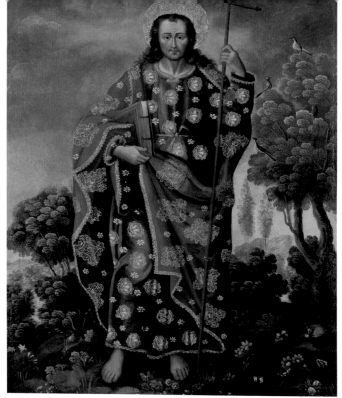

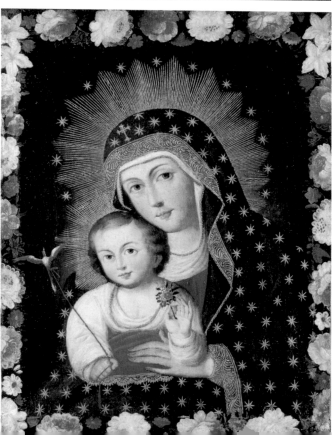

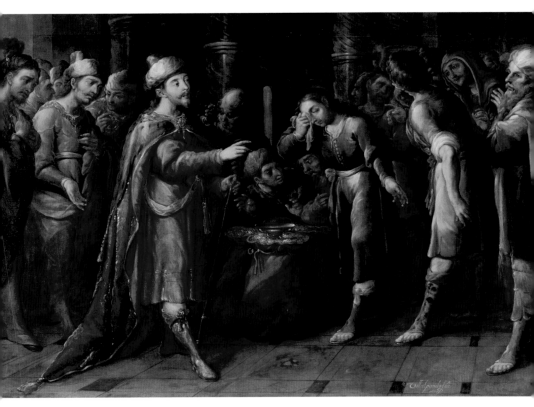

Fig. 35. Cristóbal de Villalpando, *Joseph Claims Benjamin as His Slave*. Mexico, 1700–1714. Oil on canvas. 59⅞ x 82⅝ in. Gift of Frederick & Jan Mayer; 2009.761.

consequently, to move closer to the sun god. Magnificent bird feathers were incorporated into clothing and headdresses of the Inca nobility and symbolized their exalted status. In the highland areas paintings often incorporated depictions of birds or bird feathers into images of the Virgin and Christ to indicate their sacred and honored position in colonial society (fig. 34). The importance of birds was extended to Christian angels, whose wings were often painted red, blue, and white—colors sacred to the Inca (fig. 36; pp. 46–47).

New themes developed in painting that referred to local political situations, such as the popularity of paintings about the life of Joseph of the Old Testament, who was sold into slavery by his brothers but rose to become head of state in Egypt. In colonial Mexico Joseph exemplified good government (fig. 35). Subject matter often reflected the cultural mix of the local environment, such as the popular images of the Virgin Mary as a young girl spinning wool, in which she wears an Inca-style headdress (fig. 37), or the image of Saint Joseph with the Christ Child by the well-known Bolivian artist Melchor

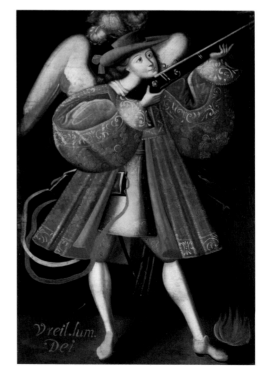

Fig. 36. Circle of Calamarca, *Archangel Uriel*. Bolivia, circa 1725. Oil on canvas. 44³/₄ x 28³/₄ in. Gift of Althea Revere; 1971.463.

Fig. 37. *Virgin Mary Spinning*. Peru, circa 1700. Oil on canvas. 25 × 21 in. Gift of Engracia Freyer Dougherty for the Frank Barrows Freyer Collection; 1969.353.

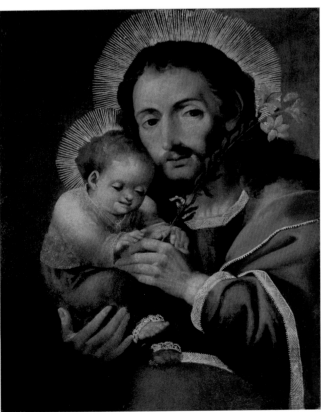

Fig. 38. Melchor Pérez Holguín, *Saint Joseph and the Christ Child*. Potosí, Bolivia, circa 1710. Oil, gold, canvas. 22³/₄ × 17³/₄ in. Gift of Robert J. Stroessner; 1992.67.

Peréz Holguín, in which the child wears a woven belt in the Andean style (fig. 38).

At the beginning of the 1700s, a new and unique genre of painting developed in Mexico and spread to South America (fig. 39). Known as *casta* (caste) paintings, these sets of fourteen to sixteen canvases portrayed mixed-race families in domestic or occupational settings, thus providing a rare glimpse into daily life in Mexico in the 1700s (fig. 40). Often commissioned for export to Spain, *casta* sets advertised the natural abundance, in both products and people, of the American territories and exhibited a new sense of chauvinism and pride about the wealth of the Americas (figs. 41–42; pp. 56–59).

Fig. 39. *De Castizo y India produce Coyote.* Mexico, circa 1760. Oil on canvas laid on panel. 31¹/₂ x 24³/₈ in. Collection of Frederick & Jan Mayer; 305.2001.

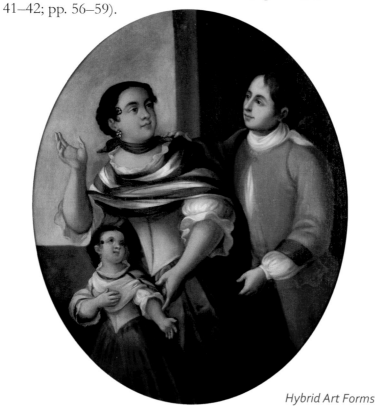

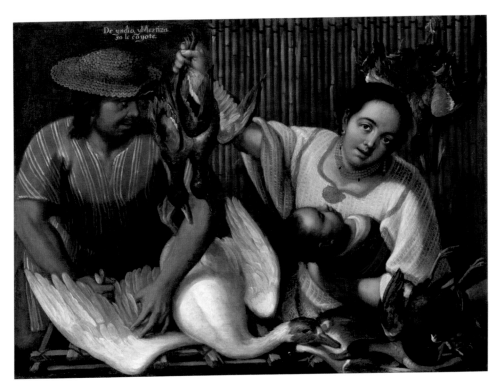

De yndio, y Mestiza
se le coyote.

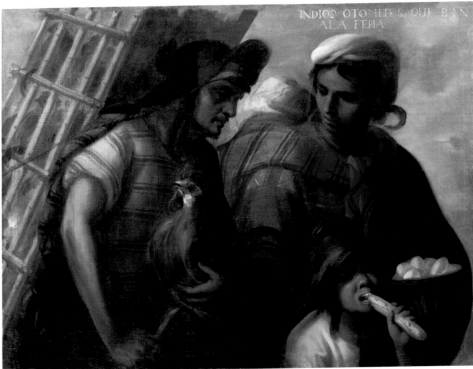

INDIOS OTOMITES QUE BAN
A LA FERIA

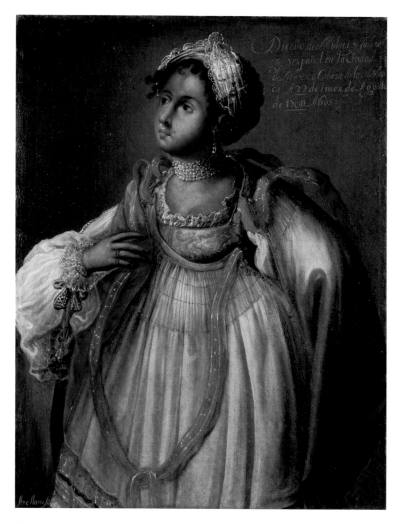

Fig. 40. (left, top) *De Indio y Mestiza sale Coyote.* Mexico, mid 1700s. Oil on canvas. 31½ x 41 in. Collection of Frederick & Jan Mayer; M2004.004.

Fig. 41. (left, bottom) Juan Rodríguez Juárez, *Otomí Indians on the Way to the Fair.* Mexico, circa 1725. Oil on canvas. 32½ x 41 in. Collection of Frederick & Jan Mayer; 18.2000.

Fig. 42. (above) Manuel de Arellano, *Rendering of a Mulatto.* Mexico, 1711. Oil on canvas. 39½ x 29⅛ in. Collection of Frederick & Jan Mayer; TL-24502.

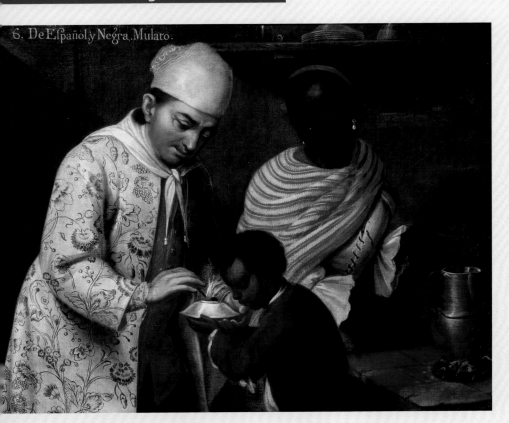

6. De Eſpañol y Negra. Mulato.

José de Alcíbar, *From Spaniard and Negro, Mulatto*. Mexico, circa 1760. Oil on canvas. 31 x 38¼ in. Collection of Frederick & Jan Mayer; TL-17535. Photograph © James Milmoe.

At the beginning of the 1700s, a new and unique genre of painting developed in Mexico. Designed to depict and classify the racial mixtures occurring among Spaniards, Africans, and Indians, these sets of paintings contain a wealth of information on the daily life, diet, occupations, clothing, habits, utilitarian objects, and recreations of the era. Executed by local artists, the new genre reflected Mexican self-image and coincided with the emergence of a burgeoning sense of nationalism.

Casta paintings were typically produced in sets of fourteen to sixteen canvases and portray families in domestic settings. This painting, which depicts a family in the kitchen of their home, is one of the most beautifully executed and intimate of this type. The African mother stands at the stove and stirs hot chocolate for her family in a tall-necked copper pot specifically developed in Mexico for its preparation

(right, bottom). The young son holds a silver brazier with hot coals for his father to light a cigarette *(right, top)*. Both chocolate and tobacco were American products, unknown in Europe before contact and quite popular there by this time.

The domesticity of the scene is emphasized by the Spanish father's clothes: he is dressed in a *banyan*, a distinctive man's dressing coat, and a white cap lined with lace, both worn exclusively in the home. Reflecting the ongoing Asian trade with Mexico, the *banyan* is made of chintz, a printed cotton produced in India and exported in tremendous quantities to the Americas via the Manila galleons *(right, middle)*. Known as *indianilla* in Mexico, chintz was used extensively by the lower and middle classes and reflects their consciousness of fashion at a time when upper classes wore Chinese silks with similar floral patterns. *Indianilla* fabrics can be seen in many *casta* paintings, particularly in skirts worn by women and girls.

Both parents wear garments distinctive to Mexico at this time. The father wears the Mexican *pañuelo* or triangular scarf at his neck; the mother wears the Mexican striped *rebozo* or rectangular shawl, ubiquitous among women of the middle and lower classes of the era, over her European-style full skirt and fitted white blouse.

The clothes, the family's activities, and the utensils reveal the hybridity of Mexican culture of the eighteenth century in their mix of European, Asian, and Mexican objects. *Castas* increasingly incorporated more American products, and used clothing and utensils to indicate occupation and status. ❧

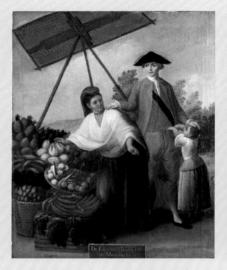
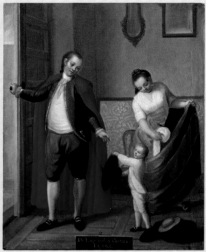
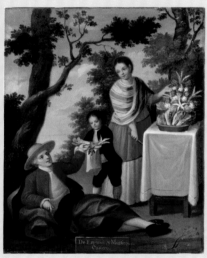
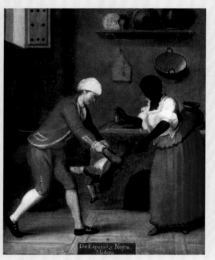

Francisco Clapera, *Casta* painting series (set of sixteen). Mexico, circa 1775. Oil on canvas. Each painting approx. 20 x 15¹⁄₂ in. Collection of Frederick & Jan Mayer; 190.1996.

(top, left) 1. *De Español, e India, nace Mestiza.*
(top, right) 2. *De Español, y Castiza, Español.*
(bottom, left) 3. *De Español, y Mestiza, Castizo.*
(bottom, right) 4. *De Español, y Negra, Mulato.*

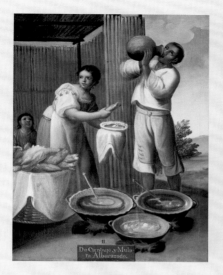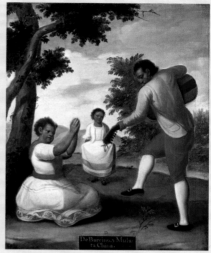

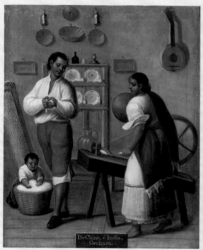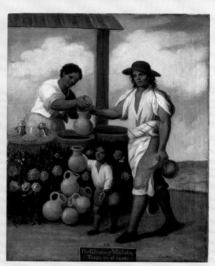

(top, left) *11. De Cambujo, y Mulata, Albarazado.*
(top, right) *13. De Barcino, y Mulata, China.*
(bottom, left) *14. De Chino, e India. Genízara.*
(bottom, right) *16. De Gíbaro, y Mulata, Tente en el ayre.*

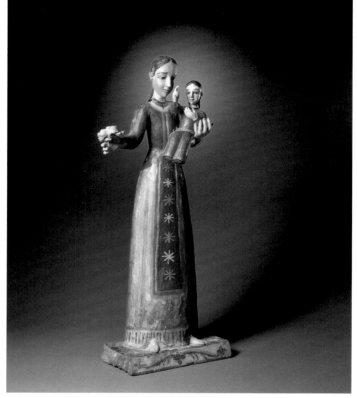

Fig. 43. Rafael Aragón, *Our Lady of Mount Carmel*. Santa Fe or Córdova, New Mexico, circa 1830. Paint, gesso, wood. 29 x 10³/₄ in. Funds from Walt Disney Imagineering; 1989.3a,b.

Fig. 44. Rafael Aragón, *Our Lady of Mount Carmel*. Santa Fe or Córdova, New Mexico, circa 1840. Paint, gesso, wood panel. 19¹/₂ x 16¹/₂ in. Gift of Morton D. May; 1969.155.

In some areas unique regional styles developed. On the northernmost frontier of the Spanish colonies in the area that now comprises New Mexico and southern Colorado, colonial artists learned from the local Pueblo Indians how to make water-based paints from indigenous vegetal and mineral pigments. Artists in New Mexico used these regional paints along with imported oil paints on carved wooden statues and panels to make images of saints distinctive to the region (figs. 43–44). Known locally as *retablos* (paintings on wood) and *bultos* (sculptures), they were combined to create large altarscreens for the local adobe churches, in imitation of the ones used in Mexico and Spain (figs. 46, 48). The tradition continues today in what is now the southwestern United States, where artists of Hispanic descent still make images of saints in this regional Spanish colonial style (figs. 45, 47).

Fig. 45. Rhonda Crespín, *Kiss of Judas*. Albuquerque, New Mexico, 1999. Pigment, leather, gesso, wood. 17 x 10 x 5¹/₂ in. Funds from Lorraine Higbie and Carl Patterson; 1999.164.

In colonial Peru, two artistic centers developed, one in Lima with heavy European influence (fig. 50); the other in Cuzco and the surrounding highland areas of the Andes mountains (including Bolivia), which incorporated stronger native inspiration and employed many native artists (fig. 49). In the highland area, a distinctive style of painting evolved that combined European artistic

Fig. 46. Pedro Antonio Fresquís, *The Holy Trinity*. New Mexico, circa 1785. Paint, gesso, wood panel. 18¼ x 36 x 1 in. Gift by exchange, Althea Revere; 1971.102.

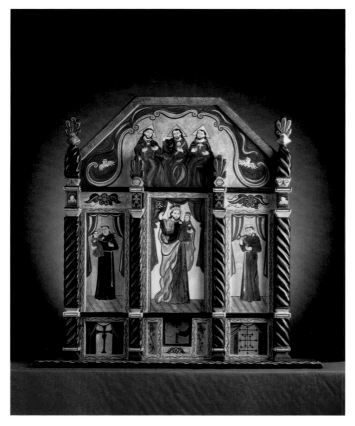

Fig. 47. Catherine Robles-Shaw, *Holy Trinity Altarscreen*. Boulder, Colorado, 1998. Paint, gesso, wood panel. 29 x 29³/₈ x 5½ in. Gift of Hope S. & Edward P. Connors; 1998.340.

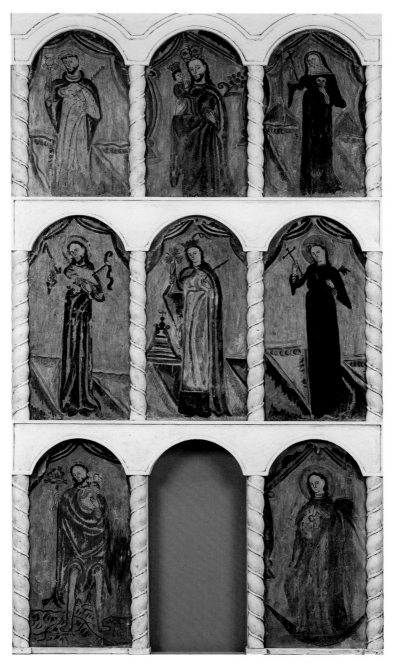

Fig. 48. Molleno, Altarscreen panels mounted in a contemporary framework. New Mexico, circa 1825. Paint, gesso, wood panel. Each panel between 22–25 x 9–12 in. Anne Evans Collection; 1936.16.

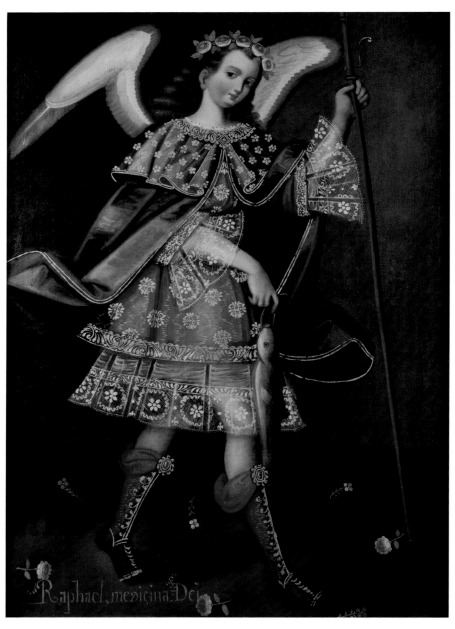

Fig. 49. *Archangel Raphael*. Peru/Bolivia, circa 1720. Oil, gold, canvas. 54¹/₂ x 39¹/₂ in. Gift of Dr. Belinda Straight; 1985.535.

traditions with native Incan iconography. The extraordinary use of gold decoration on paintings is exclusive to the highland areas of Peru and Bolivia (pp. 46–47). Known as *broceatado* (brocade) or *sobredorado* (gold overlay) in Spanish, it was created by applying gold leaf over small raised applications of gesso (figs. 49, 51–52). It imitates the elaborate brocade fabrics of the era. The highland areas were also known for elegant textile weaving traditions both before and after the Spanish conquest. The development of gold patterning on fabrics in Andean colonial painting may reflect the local emphasis on beautiful textiles.

Ecuador became renowned in the 1700s for exquisitely carved small sculptures that were exported to other areas of colonial Latin America and to Europe (fig. 54). The Ecuadorian sculptors devised a new *estofado* technique similar to that used on *broceatado* paintings in Cuzco with the gold designs applied over raised areas of gesso rather than underneath the paint layers. The city of Popayán in Colombia became well known for its exquisite traditional *estofado*

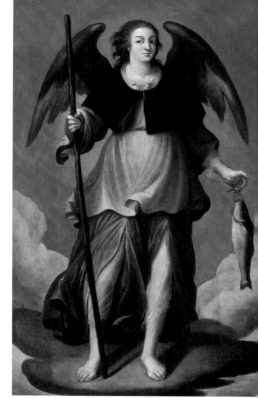

Fig. 50. *Archangel Raphael*. Lima, Peru, circa 1640. Oil on canvas. 63 x 33¹/₂ in. Gift of Drs. Sydney G. & Virginia M. Salus; 1979.180.

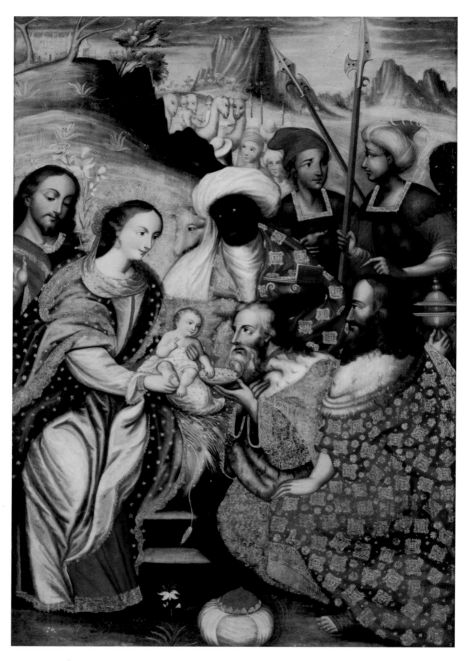

Fig. 51. Marcos Zapata and Cipriano Toledo y Gutiérrez, *Adoration of the Magi*. Cuzco, Peru, circa 1760. Oil, gold, canvas. 74 x 49⁵/₈ in. Gift of Mr. & Mrs. Frank Barrows Freyer II for the Frank Barrows Freyer Collection; 1969.347.

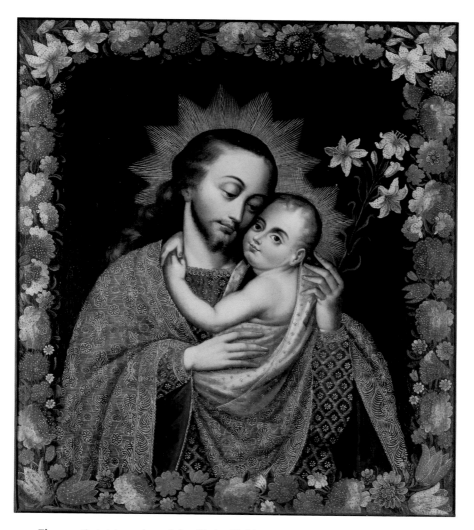

Fig. 52. *Saint Joseph and the Christ Child.* Cuzco, Peru, early 1700s. Oil, gold, canvas. 31¼ x 26½ in. Gift of Engracia Freyer Dougherty for the Frank Barrows Freyer Collection; 1969.354.

Fig. 53. *Ecce Homo.* Popayán, Colombia, mid 1600s. Oil on canvas. 21 x 19¹/₂ in. *Estofado* frame: Popayán, Colombia, mid 1600s. Wood, paint, gold. 35 x 32¹/₂ in. Gift of the Stapleton Foundation of Latin American Colonial Art, made possible by the Renchard Family; S-106.

work (fig. 53) as well as for a lively style of silverwork (fig. 55). As a result of vast New World mines, the silversmiths of Mexico, Peru, and Bolivia manufactured prodigious quantities of silver utensils with distinctive regional styles (fig. 56, pp. 72–75). For example, the highland areas of Peru and Bolivia specialized in elaborate filigree animals, a technique continued from Inca times (fig. 57).

Fig. 54. *Virgin of Quito*. Ecuador, circa 1750. Paint, wood, gold, gesso, silver. 17¹/₂ x 9¹/₂ x 6¹/₂ in. Gift of Mr. & Mrs. John Pogzeba; 1974.265.

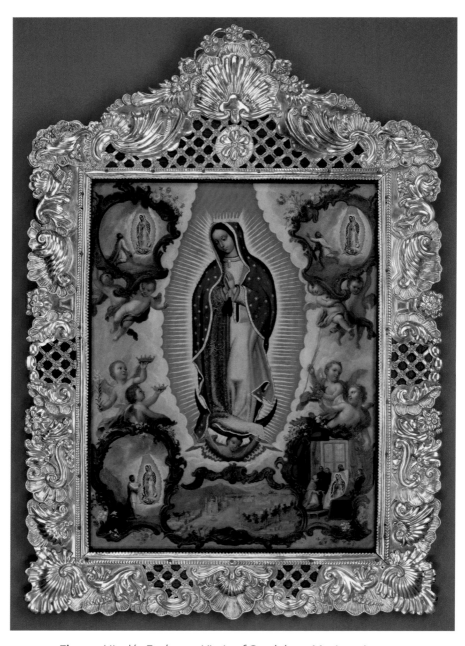

Fig. 55. Nicolás Enríquez, *Virgin of Guadalupe*. Mexico, circa 1740. Oil on copper. 33¼ x 25 in. Frame: Popayán, Colombia, mid 1700s. 52¾ x 35¾ in. Collection of Frederick & Jan Mayer; 191.1996.

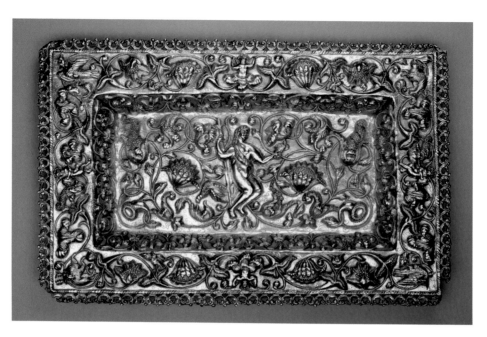

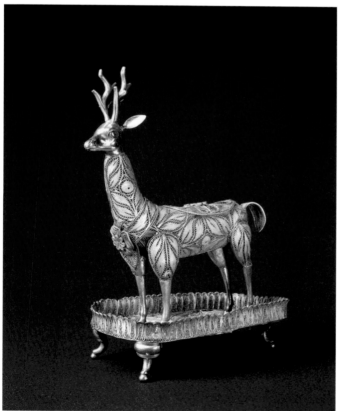

Fig. 56. Platter. Bolivia, 1725-50. Silver. 13³/₄ x 21 in. Gift of the Robert C. Appleman Family; 1986.456.

Fig. 57. Deer. Peru, late 1700s. Silver filigree. 9 in. Gift of the Robert C. Appleman Family; 1992.385.

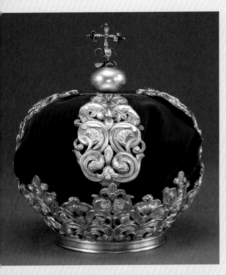

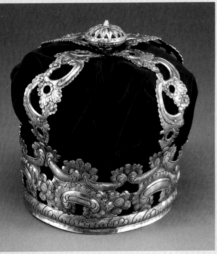

When Hernán Cortés and his troops arrived in Mexico in 1519, to their delight they found that gold and silver were abundant. The Mexican Indians had a long tradition of metalworking techniques, including filigree, casting, and hammering. In his second letter to Charles V, Cortés described numerous gold and silver objects he was sending as gifts and hinted at the merger of European and native traditions already taking place:

> *All the things of which Moctezuma has heard, whether on land or sea, they have modeled very realistically either in gold or silver…and with such perfection that they seem almost real. He gave many of these for your Highness, not counting other things which I drew for him and which he had made in gold, such as holy images, crucifixes, medallions, ornaments, necklaces, and many other of our things.*

When Cortés's gifts to the king were exhibited in Brussels in 1520, the German artist Albrecht Dürer described his response to Aztec craftsmanship:

> *I have seen the objects they have brought to the king from the new golden land: a sun of solid gold that measures a full fathom; also a moon of pure silver, equal in size….and have been left amazed by the subtle inventiveness of the men of faroff lands.*

After the conquest of Mexico the Franciscan friar Motolinía described the expertise of Mexican indigenous metalsmiths:

Top & Bottom: Crown. Mexico, circa 1700. Silver gilt. 4³/₄ x 4³/₄ in. Crown. Mexico, circa 1770. Silver. 7¹/₄ x 6³/₄ in. Gifts of Robert C. Appleman Family, 1992.393, 1980.318. **Right**: Tiara. Colombia/ Ecuador, circa 1730. Silver gilt, emeralds, pearls. 2¹/₂ x 5¹/₂ x 3³/₄ in. Gift of Robert J. Stroessner, 1992.74.

They surpass the silversmiths of Spain in that they fashion a bird which moves its tongue, its head and its wings. Similarly, they fashion a monkey or some beast that moves its head, tongue, feet, and claws; and in its claws they place some little playthings that seem to dance with them. Best of all, they fashion a fish with all its scales, some of gold and others of silver.

Silversmiths from Spain began to immigrate to Mexico shortly after the conquest and introduced European forms and styles. Documents regulating the production of metalwork in Mexico date from as early as 1526, indicating that a thriving and competitive industry was underway by that time. Although Indian silversmiths were prohibited from joining the guilds, they worked outside them, particularly for the monastic orders, and as unofficial assistants to master craftsmen.

Gold and silver shops were grouped together on Platería Street in downtown Mexico City and provided objects for church and domestic use as well as personal jewelry. In 1625 the British Dominican friar Thomas Gage described the street by saying that "a man's eyes may behold in less than an hour many millions' worth of gold, silver, pearls, and jewels." Still today a high concentration of jewelry stores can be found in this area of Mexico City.

Silver objects made during the early colonial period often appear at first glance to be derivative of Spanish styles. Upon closer inspection, however, a New World detail always sets the piece apart, however subtly. Through time this synthesis of New and

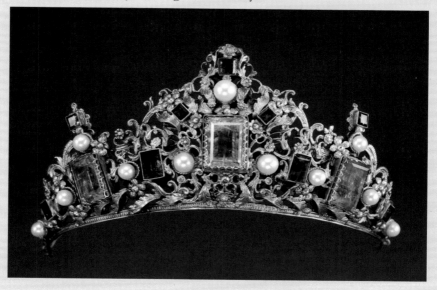

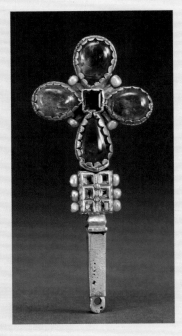

Old World styles became more integrated, culminating in the lush excesses of colonial Baroque and Rococo silverwork ornamentation with tightly woven scrolls, flowers, and vine decoration as seen in the large Mexican crowns made for statues of saints or the Virgin Mary (p. 72).

The Indians of modern-day Peru, Ecuador, and Colombia had a tradition of silver- and goldwork as well as significant local access to both metals. Guilds in South America were slower to be founded and less influential than in Mexico. As a result, silverwork from South America, particularly from Peru and Colombia, retained an even stronger indigenous flavor.

The abundance of emerald mines in South America, particularly in Colombia, made the addition of these valuable stones common in metalwork from the Americas. The emeralds in these pieces *(left)* have been identified as coming from the famous emerald mines in Colombia, with some of them from the large Muzo mine, known for the exceptional quality and clarity of its stones. In microscopic analysis, the tear-shaped emeralds in the gold cross show evidence that they were originally cut with Pre-Columbian quartz stone tools to form beads. In the colonial period they were reshaped with metal tools to be incorporated into the gold cross to serve as an ornament at the top of a crown for a statue of a saint or the Virgin Mary. The pearls used on the cross have been identified as Venezuelan, most likely from the famous Island of the Margaritas off the coast.

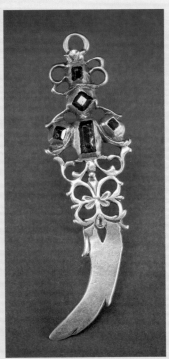

Emeralds from the New World became very popular in Europe in the 1600s and were used for all manner of jewelry for both men and women on both continents (p. 5). The elegant tiara with emeralds and pearls may have been worn by a young woman in South America for formal occasions or it may have graced an image of the Virgin Mary or a saint (p. 73). The small gold dagger with Muzo emeralds may have pierced the heart of a small statue of the Virgin of Sorrows, symbolizing her sorrow at the Crucifixion of her son Jesus, or it may have hung from a chain as jewelry worn by a man or woman (*opposite, bottom*).

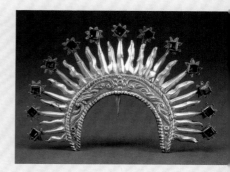

Emeralds were so popular during the seventeenth and eighteenth centuries that they were imitated by using green glass and even green paste stones. The gold halo has green glass stones at the ends of the rays of light *(right, top)*.

Such metal ornaments and jewelry are still made today throughout the Spanish Catholic world, including in the southwestern United States, as exemplified by the small silver crown made in the year 2000 by the young artist Bo López *(right, bottom)* from Santa Fe, New Mexico. ❧

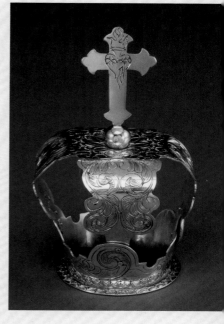

Left, top: Cross Finial. Colombia, circa 1600. Gold, emeralds, pearls. 4 x 1¹/₂ in. Gift of the Stapleton Foundation of Latin American Colonial Art, made possible by the Renchard family; S-519.
Left, bottom: Dagger. Colombia/Ecuador, circa 1650. Gold and emeralds. 2¹/₂ x ¹/₂ in. Gift of Stapleton Foundation of Latin American Colonial Art, made possible by the Renchard family; S-518.
Top: Halo. Colombia/Ecuador, circa 1770. Silver gilt and green glass. 3³/₄ x 5¹/₄ in. Gift of the Stapleton Foundation of Latin American Colonial Art made possible by the Renchard family; S-558.
Bottom: Bo López, Crown. Santa Fe, New Mexico, 2000. Silver. 5 x 2³/₄ x 3 in. Gift of the Spanish Colonial Arts Society; 2000.65.

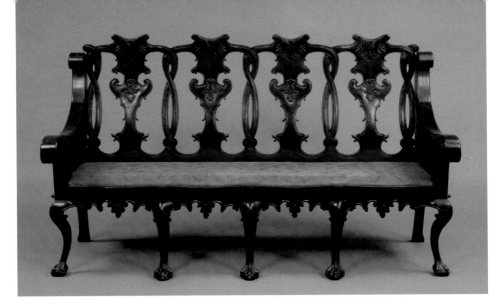

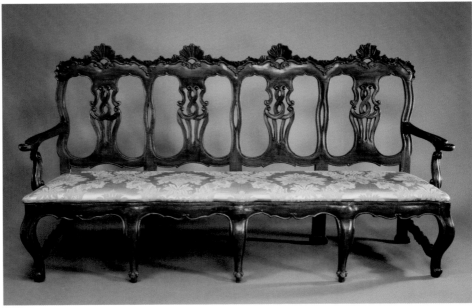

Fig. 58. (top) Settee. Mexico, circa 1770. Mahogany. 46 x 72¹/₄ x 28¹/₂ in. Collection of Frederick & Jan Mayer; 27.1993.

Fig. 59. (bottom) Settee. Peru, circa 1770. Mahogany. 49 x 86 x 25 in. Gift of John C. Freyer for the Frank Barrows Freyer Collection; 1969.375.

Following basic European styles, furniture made in the Americas developed regional variations. Proportions in the New World were often grander and heavier than their European counterparts and the decoration was often more ornate (figs. 58–60). As in Europe, brightly painted furniture became popular during the 1700s (figs. 61, 63). Marquetry work, a highly developed art form in Spain since Muslim times, was equally exquisite in the Americas with local details incorporated alongside European allegorical and classical imagery. Regions such as Puebla in Mexico and areas of Ecuador and Peru excelled in the marquetry technique and evolved distinctive styles (figs. 62, 64). In some examples, Asian influence can be seen in Latin American furniture, with the most obvious case being the *biombo* or folding screen, a form invented in Asia and introduced to the Western world with the opening of trade (pp. 100–103).

Fig. 60. Bench. New Mexico, early 1800s. Pine. 41^1/$_2$ x 82^1/$_4$ x 24 in. Museum purchase; 1971.15.

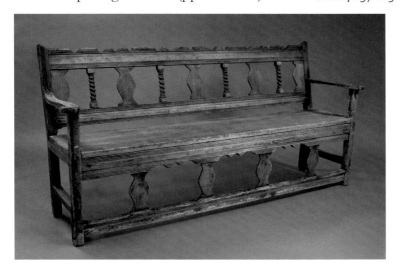

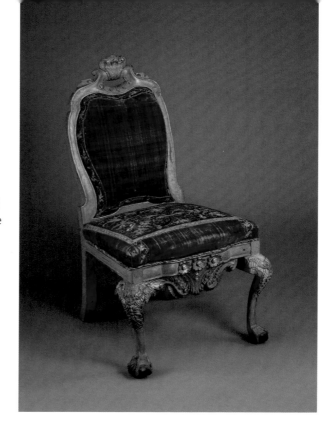

Fig. 61. Chair. Probably Colombia, 1700s. Polychromed wood, gesso, gold leaf, velvet upholstery. 46 in. Gift of the Stapleton Foundation of Latin American Colonial Art, made possible by the Renchard Family; S-1.

Fig. 62. Writing Desk. Mexico or Peru, late 1600s. Wood, tortoise shell, bone, mother of pearl. 36¹⁄₄ x 38¹⁄₂ in. Collection of Frederick & Jan Mayer; 114.1999.

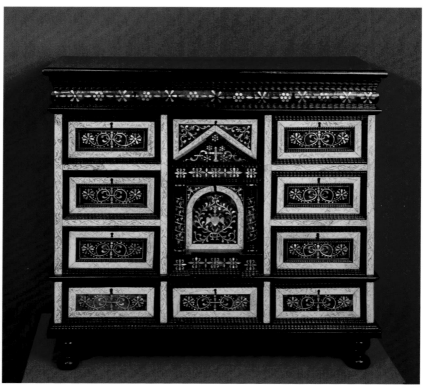

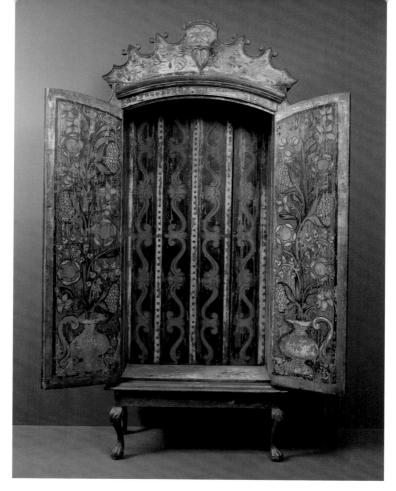

Fig. 63. Cabinet. Paraguay, circa 1750. Paint on wood. 71^1/$_2$ x 36^1/$_4$ in. Anonymous gift; 1992.44.

Fig. 64. Lap Desk. Ecuador, late 1700s. Wood, hardwood inlay, silver. 8 x 12^1/$_2$ x 17^1/$_2$ in. Gift of the Stapleton Foundation of Latin American Colonial Art, made possible by the Renchard Family; S-49.

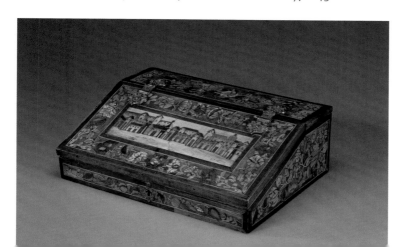

Fig. 65. Water Jar. Porto Bello, Panama, late 1500s. Earthenware, clay slip paint. 18 x 21¹/₂ in. Gift of Dr. M. Larry and Nancy B. Ottis; 2001.897.

Fig. 66. Duck Vessel. Tonalá (Jalisco), Mexico, 1700s. Earthenware with clay slip paints. 8¹/₄ x 8 x 11¹/₄ in. Alianza de las Artes Americanas, Spain Trip 2001; 2002.4.

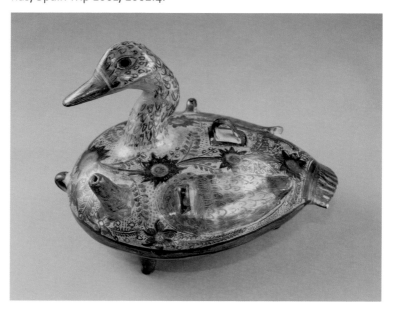

Colonial ceramics demonstrate multicultural inspiration from native, European, Islamic, and Asian traditions. Hand-built from mud and low-fired to harden, earthenware vessels were produced throughout the Americas for thousands of years before the arrival of Europeans. During the colonial period, earthenware produced by native peoples in the Americas became popular in Europe and the Americas for storing water (fig. 65). The slightly porous quality of the vessels was reputed to absorb bad odors in the water and to "purify" it, much like water filters today. Vessels were exported to Spain and graced the tables of many upper-class Spanish homes (figs. 66–67).

Earthenware covered with a hard, shiny glaze made from lead and tin had been invented in the Middle East. The technique (known as majolica), along with the potter's wheel, was introduced to Spain by Muslims in the 900s. In turn, Spanish ceramic artists introduced majolica production to the Americas in the 1500s. Pigments embedded in the glaze enabled potters to create colorful decorations on their vessels. The colonial towns of Puebla (Mexico) and Lima (Peru) became centers of majolica production (figs. 68–69). They created distinctive styles that often incorporated a mixture of motifs taken from earlier Islamic, Spanish, and ancient native models as well as from imported Chinese porcelains (fig. 70).

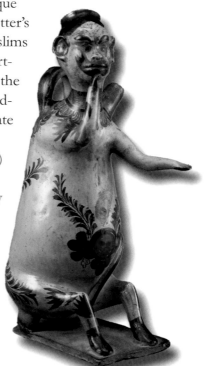

Fig. 67. Monkey Vessel. Tonalá (Jalisco), Mexico, 1700s. Earthenware with clay slip paints. 13$^{1}/_{4}$ x 4$^{1}/_{4}$ x 7 in. Alianza de las Artes Americanas, Spain Trip 2001; 2002.5.

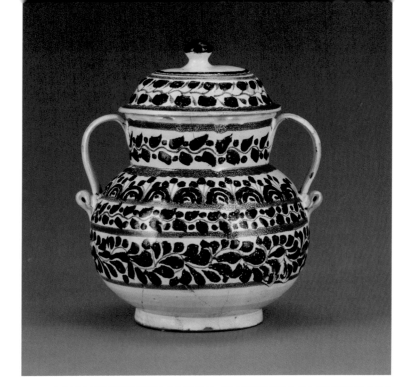

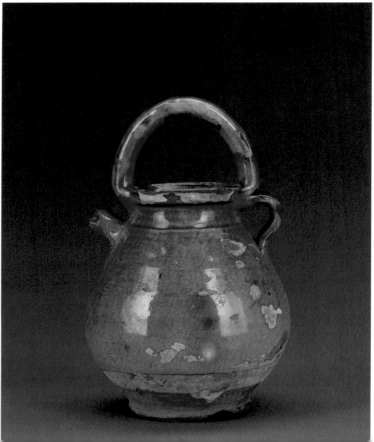

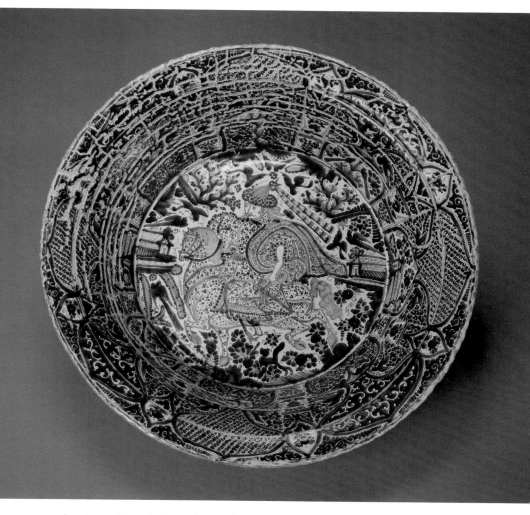

Fig. 68. (left, top) Jar with Handles and Lid. Puebla, Mexico, late 1700s. Earthenware, lead/tin glaze, cobalt in-glaze paint. 10⅝ x 7⅞ in. Gift of Robert J. Stroessner; 1984.178.

Fig. 69. (left, bottom) Jug. Peru, 1800s. Earthenware, lead/tin glaze. 10¾ x 6 in. Gift of John C. Freyer for the Frank Barrows Freyer Collection; 1974.260.

Fig. 70. (above) Basin *(Lebrillo)*. Puebla, Mexico, late 1600s. Earthenware, lead/tin glaze, cobalt in-glaze paint. 6 x 26 in. Funds from 2001 Collector's Choice; 2001.314.

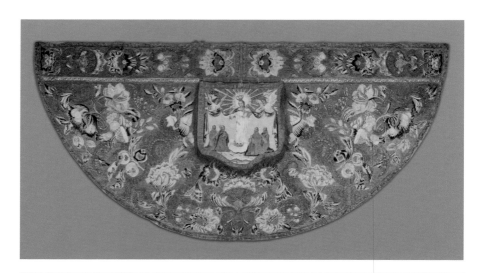

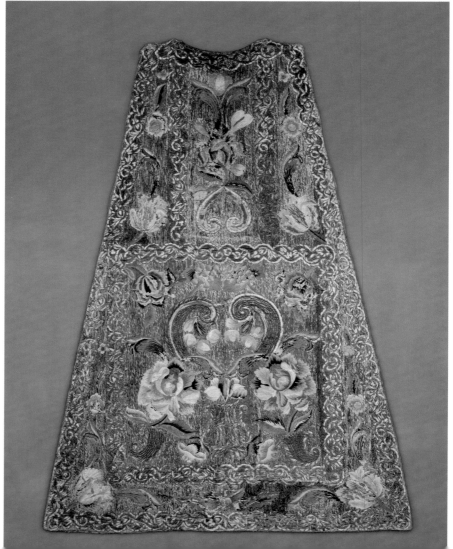

Fabrics were yet another aspect of the international exchange of the period. Cotton and *ixtli* (maguey or agave fiber) were native to the Americas and unknown in Europe; linen and wool were native to Europe and unknown in the Americas; silks were brought to both areas from Asia. The exchange of dyes between continents revolutionized textile industries in all areas with the most notable example being the introduction of American cochineal red dye, made from a small insect that lives on the nopal cactus, to both Europe and Asia. The ensuing cultural mix of materials, dyes, techniques, and motifs produced impressive textiles in the Americas. Traditional Andean weavings continued with new inspirations and dyes from Europe and Asia. Silk vestments for church services were made in Asia for the American and European markets and were embroidered by nuns in the colonial convents of the Americas (fig. 71). As in Europe, the education of all young women included detailed embroidery techniques (fig. 72). Bedspreads and blankets were woven in complicated patterns with some areas, such as Peru and Saltillo (Mexico), producing exceptional examples (fig. 73). In many areas of the Americas, traditional textiles are still produced today.

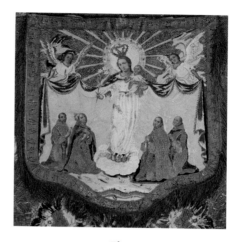

Fig. 71. Liturgical cope and chasuble. Mexico, circa 1750. Embroidered metal and silk thread on jute ground. Collection of Frederick & Jan Mayer; TL-05593, TL-05594.

Fig. 72. Blanket. Mexico, 1775. Wool crewel work embroidery on cotton. 92½ x 58½ in. Neusteter Textile Collection: Gift of the Frederic H. Douglas Collection; 1956.54.

Fig. 73. Blanket. Mexico, late 1800s. Wool. 79 x 60 in. Neusteter Textile Collection: Gift of Mrs. W. A. Butchart; 1945.235.

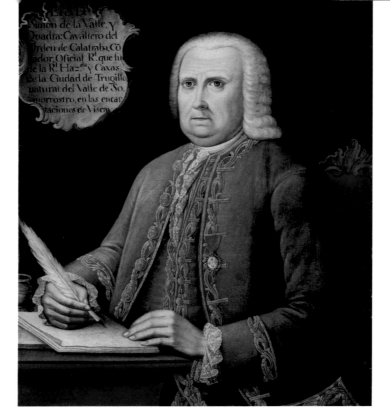

D. ...
...mon de la Valle, y
...uadra: Cavallero del
...rden de Calatraba, Cō
...dor Oficial Rl. que fu...
...de la Rl. Hazda. y Caxas
...de la Ciudad de Trugillo
...natural del Valle de So...
...morrostro, en las encar...
...taciones de Viscay...

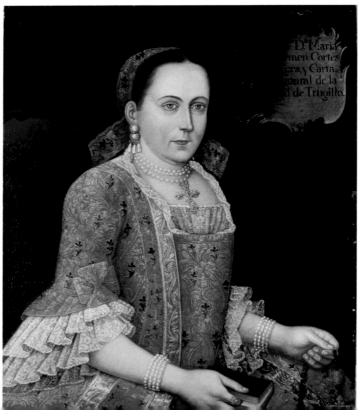

Dª Maria
...men Cortés
...es, y Carta...
...tural de la
...d de Trugillo.

88

As in Europe, portraiture became increasingly important in colonial Latin America. Throughout history, portraits have helped to fulfill the desire for immortality by commemorating lives, ancestry, and accomplishments. In general, the artists of colonial Latin America followed the canons accepted for official and courtly portraiture in Europe, with figures portrayed in three-quarter view gazing directly at the viewer and flanked by drapery. In the Americas, the focus on social standing often overshadowed any effort to convey the essential personality of the subject. Although the artists accomplished a physical likeness, the faces often show little expression (figs. 74–75). Instead the artists focused their attention on depicting the allegorical content and rich details of luxurious clothing and surroundings. Sometimes objects related to the sitter's accomplishments or possessions were included in the picture (figs. 76–77). In Latin America, coats-of-arms and cartouches or bands bearing inscriptions outlined the sitter's heritage or honors.

In the early colonial period, surviving portraits usually depict religious, civil, or military officials (fig. 78), or donors of charitable or religious works (figs. 26, 79, 81–82). Throughout the colonial period, native peoples, particularly those descended from Pre-Hispanic nobility, strove to negotiate their role within the colonial hierarchy by documenting their noble status through portraiture (figs. 80–82).

Figs. 74, 75. *Portraits of Simón de la Valle y Cuadra and María del Carmen Cortés Santelizes y Cartavio.* Peru, circa 1750. Oil on canvas. 30¹/₂ x 25 in. Funds from Frederick & Jan Mayer, Carl & Marilynn Thoma, Jim & Marybeth Vogelzang, Harley & Lorraine Higbie; 2000.250.1&2.

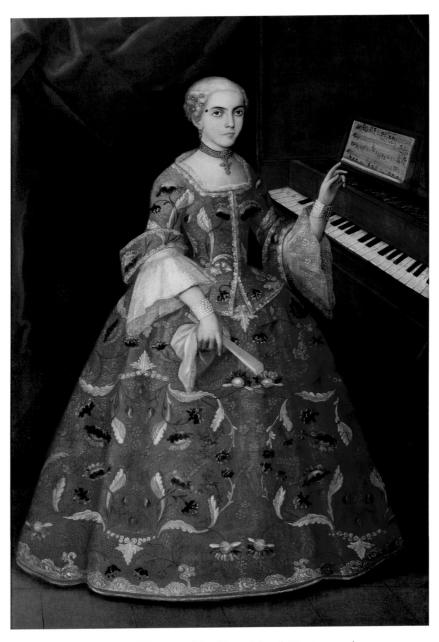

Fig. 76. *Young Woman with a Harpsichord*. Mexico, early 1700s. Oil on canvas. 61⅝ x 40⅜ in. Collection of Frederick & Jan Mayer; 3.2007.

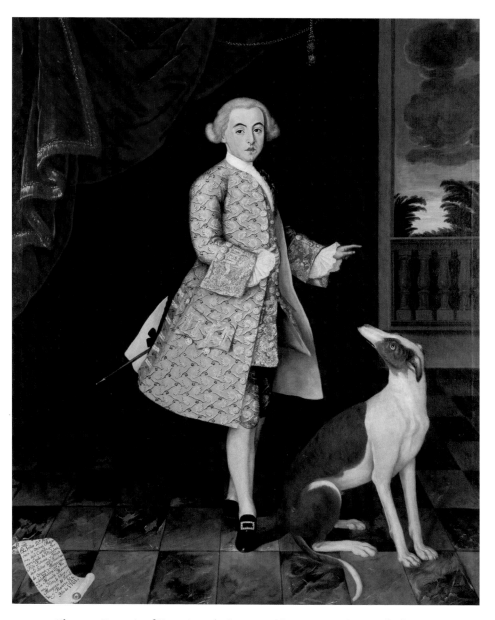

Fig. 77. *Portrait of Francisco de Orense y Moctezuma, Count of Villa-lobos*. Mexico, 1761. Oil on canvas. 74 x 59 in. Collection of Frederick & Jan Mayer; 144.2005.

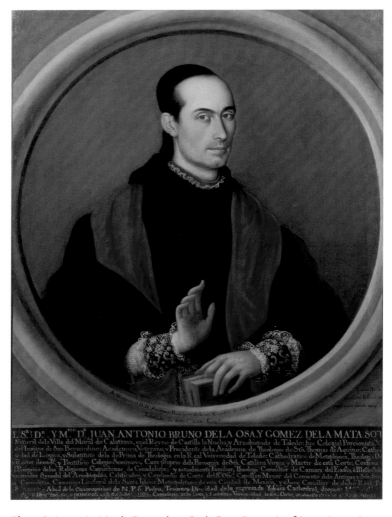

Fig. 78. Ignacio María Barreda y Ordoñes, *Portrait of Juan Antonio Bruno de la Osa*. Mexico, circa 1800. Oil on canvas. 40¹/₄ x 29¹/₈ in. Collection of Frederick & Jan Mayer; M1997.013.

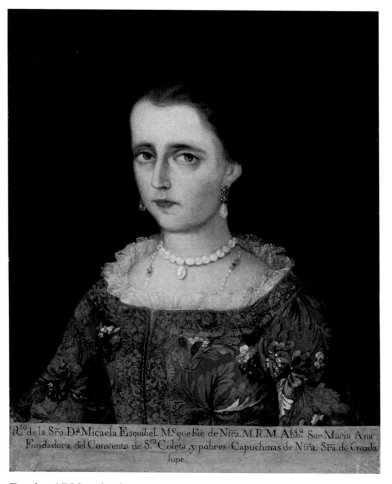

R.^{to} de la Sra. D.^a Micaela Esquibel. M.^e que fue de Ntra. M.R.M. Abb.^a Sor Maria Ana Fundadora del Convento de S.^{ta} Coleta y pobres Capuchinas de Ntra. Sra. de Guadalupe.

By the 1700s, the burgeoning and upwardly mobile middle class in Latin America, mostly made up of wealthy merchants and miners, instigated a tremendous increase in portraiture and decorative arts as they sought to solidify their standing in society (fig. 83). In addition, more secular scenes began to be depicted such as *casta* paintings and on the new genre of Garden Party folding screens, inspired by Asian examples but produced in Mexico (pp. 100–103).

Fig. 79. *Portrait of Doña Micaela Esquibel.* Mexico, circa 1750. Oil on canvas. 31³/₄ x 16¹/₂ in. Gift of Robert J. Stroessner; 1991.1166.

Fig. 80. *Inca Princess*. Cuzco, Peru, early 1800s. Oil on canvas mounted on board. 18 x 14⁷/₈ in. Gift of Dr. Belinda Straight; 1996.18.

Fig. 81. *Double Portrait of Donors*. Tlaxcala, Mexico, late 1600s. Oil on canvas. 22¹/₂ x 27³/₄ in. Collection of Frederick & Jan Mayer; M1984.099.

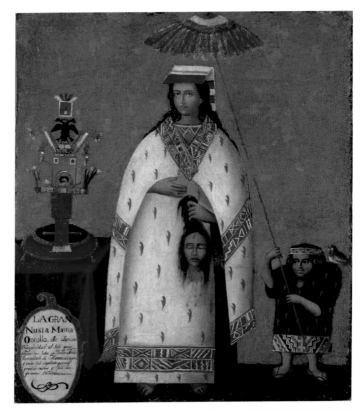

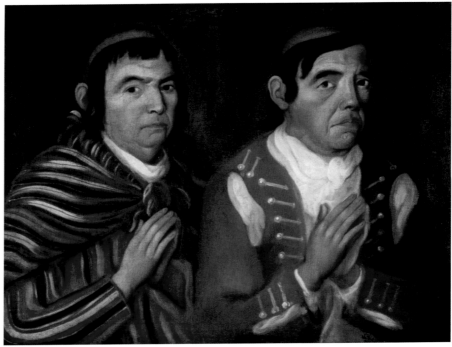

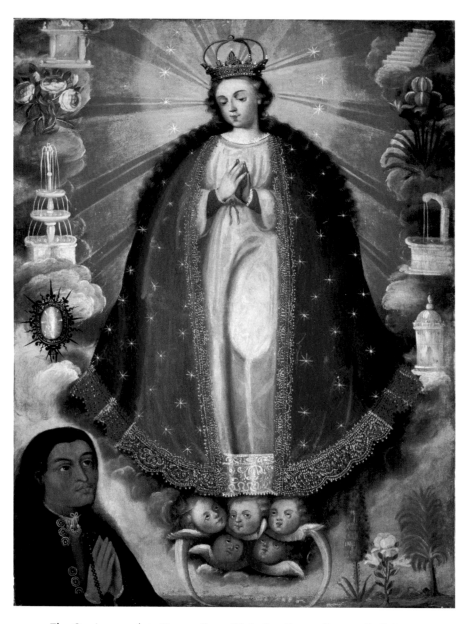

Fig. 82. *Immaculate Conception with Indian Donor*. Peru or Bolivia, early 1700s. Oil, gold, canvas. 39³/₄ x 35¹/₄ in. Gift of Mr. & Mrs. Frank Jager; 1978.118.

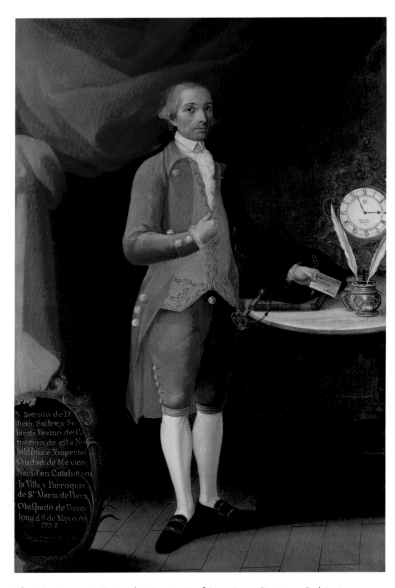

Fig. 83. Ignacio Estrada, *Portrait of Don Juan Sastre y Subirats.* Mexico, 1788. Oil on canvas. 77 x 50 in. Collection of Frederick & Jan Mayer; M1996.044.

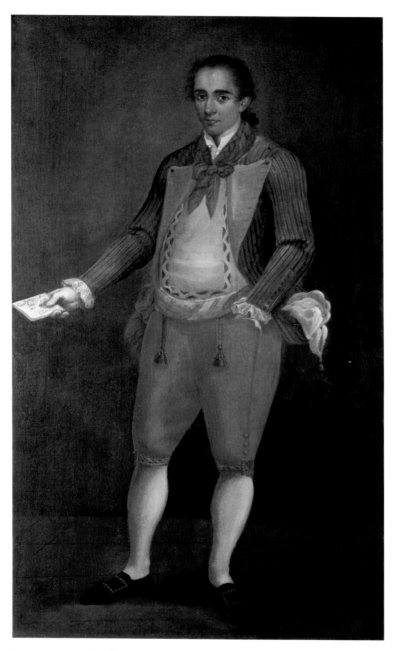

Fig. 84. Juan de Sáenz, *Portrait of Francisco Musitu Zalvide*. Mexico, circa 1795. Oil on canvas. 64³/₄ x 36³/₄ in. In memory of Frederick Mayer with funds provided by Harley & Lorraine Higbie, Carl & Marilynn Thoma, and Alianza de las Artes Americanas; 2008.27.

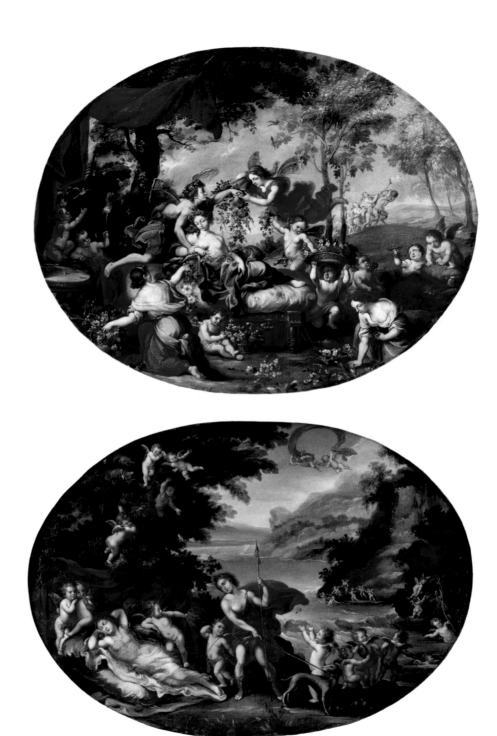

As the intellectual ideas of the Enlightenment spread in the mid-1700s, art academies were founded in Europe and Mexico City. Portraiture became less ostentatious and more attention was focused on capturing the personality and intellect of the sitter (fig. 84). Subject matter in painting included more emphasis on the classics, science, and secular themes (figs. 85–86, pp. 100-103).

Many areas of Latin America were prosperous, with extensive natural resources, and American-born citizens began to chafe under governance from Spain. As in Europe, the series of revolutions and independence movements that rocked the political world in the late 1700s had repercussions in the arts. Inspired by the success of the fledgling United States in achieving independence from Britain, the Mexican revolution began in 1810 and succeeded in gaining independence from Spain in 1821. Other areas of Latin America soon followed in the quest for independence. In art, the political changes affected but did not end the distinctive New World traditions that had developed during the era of cultural merger and global trade. In fact, many of the traditions established during this period endure today.

Fig. 85. (left, top and detail, above) Antonio Enríquez, *Homage to Venus*. Mexico, 1735. Oil on canvas. 21³/₄ x 30 in. Gift of Horace & Jane Day; 1987.192.

Fig. 86. (left, bottom) Antonio Enríquez, *Venus and Adonis*. Mexico, 1735. Oil on canvas. 21³/₄ x 30 in. Gift of Horace & Jane Day; 1987.191.

Garden Party on the Terrace of a Country Home. Mexico, circa 1725. Oil, gold, canvas. 87 x 219 in. Gift of Frederick & Jan Mayer; 2009.759.

After the Spanish occupation of the Philippines in 1561, Spain opened its own official trade route to Asia. Exotic goods—such as spices, silks, porcelains, lacquerware, printed cottons from India, and folding screens—were loaded onto the famous Spanish galleon ships for the long journey across the Pacific to Acapulco. The goods were offloaded onto mules for the overland trip across the mountains to Mexico City for sale or all the way to Veracruz, where they traveled to Spain on the Atlantic galleons—provided they could get through the gauntlet of French, Dutch, and English pirates.

Used in homes to divide spaces, block drafts, and provide privacy, the folding screen was invented in China, perfected in Japan, and introduced to the Western world through trade with Asia. Although folding screens probably arrived in Mexico earlier, the first documented ones brought to Mexico from Asia were carried as official gifts by an ambassador from Japan in 1609. By the mid 1600s, in addition to the expensive imported

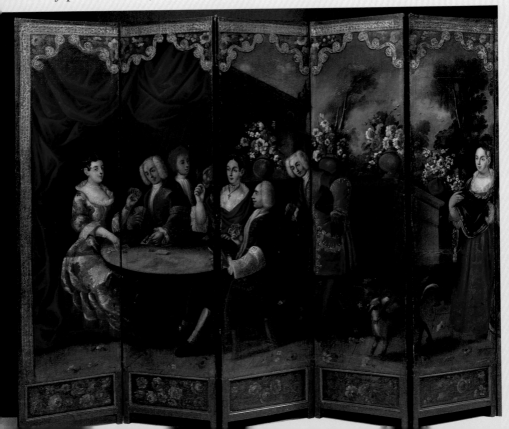

screens, local artists in Europe and Mexico were making their own screens in imitation of Asian ones. These artists used oil-on-canvas paintings instead of watercolors on paper for their locally produced screens.

By the early 1700s, a new genre of screen was invented in Mexico City that showed people enjoying a leisurely afternoon on the garden terrace of a country home. These screens provide a glimpse into upper class life and recreation in Mexico during the season of summer parties in the early 1700s. Much as they would at an afternoon barbeque today, the people in the screens play cards, gamble, smoke, flirt, drink, play music, and dance.

A careful examination of the screen reveals many interesting details. On the far left, men and women dressed in party clothes sit around a table playing cards. The coins and small beans on the table indicate that they are gambling. They use cards of an older design originally based on tarot cards *(above details, left and right)*. The clubs are wooden clubs, spades are daggers, hearts are cups or chalices, and diamonds are gold coins.

The woman on the right side of the table holds a lighted cigarette and

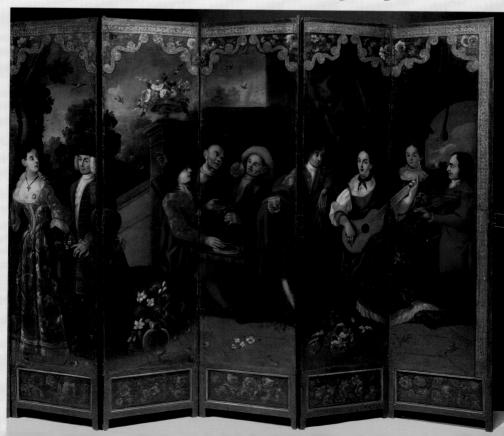

the man behind her holds a lighted cigar *(left)*. Tobacco was a New World product unknown in Europe before contact with the Americas but extremely popular there by this time. In Europe only men smoked tobacco. In the Americas it was completely acceptable for women of all classes to smoke.

In the center section of the screen, two women appear to have just entered the party with their dog. A gentleman approaches them, touching one woman on the shoulder as he reaches for her hand *(right, bottom)*. She turns to him with a pleasantly surprised expression, but her dog appears to snarl at the man. As the century progressed, such scenes of male-female interaction or flirtation became more overt in the Garden Party screens with some encounters bordering on risqué. On the right side, several gentlemen are seated around a table drinking red wine and eating a snack. They appear to sing along with the musicians next to them.

The clothing of the people in the screen is faithful to the era. The men's coats have wide cuffs and pocket flaps as well as gold or silver embroidered decorations. They wear powdered white wigs, knee breeches, and stockings that are embellished with gold or silver embroidery at the ankles *(left, middle)*. Two men have elegant tricorn hats, one wears a casual tan "blow-back" hat, and yet another has a wide-brimmed black hat over a head scarf.

The man standing next to the musicians appears to wear a cinnamon-colored buckskin suit under his poncho *(left, bottom)*. Buckskin or chamois, a type of brain-tanned leather, was unknown in Europe before it was adopted from native Americans. Soon casual suits made of supple buckskin were developed in Mexico. Often embroidered with silver thread, they were exported to Europe where they were known in English as "buffcoats" or "buffsuits" and worn for hunting or "sport."

The women in the screen wear fashionable full

skirts, fitted bodices, and white linen chemises with lace ruffles at the cuffs and neckline. They sport elaborate jewelry of gold, pearls, and jet. Many wear fake beauty marks *(chiqueadores)* made from black velvet or tortoiseshell on their temples—the height of fashion among women in Europe and the Americas *(right, top)*. The woman in the center wears an embroidered glove and holds a closed fan in her right hand, popular on both continents at this time *(right, bottom)*.

Both women in the band wear the distinctive Mexican striped *rebozo* or rectangular shawl. The woman playing the guitar wears a red and green striped *rebozo* with fringe *(right, middle)*, while the standing woman wears a rust and dark blue or black version with embroidered flowers. Both types are still made in Mexico today. The woman with the guitar also wears the distinctive Mexican *pañuelo* or triangular scarf tied around her neck. Worn by both men and women in Mexico, this useful accessory evolved into the silk do-rag or the cotton bandanna of the Mexican, and later the American, cowboy.

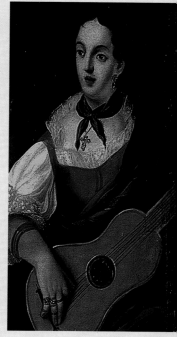

As is the case with most Garden Party screens, the people on the left appear more richly or formally dressed than those on the right. The precise social reason for this is still unknown. It may indicate that both upper and middle class people participated in these festivities. Or it may represent the upper class owners of the summer home and their guests on the left and the servants or employees, also participating in the party, on the right.

Based on the clothing and other details, this screen has been dated to between 1720 and 1730, which makes it the earliest known example of the Garden Party screen anywhere and important to the development of the genre. There are only about a dozen Garden Party screens known today; most are in private collections. The Denver Art Museum's screen is the only one in a museum in the United States. ❧

Recommended Reading

Sources Quoted:

Hernán Cortés: Letters from Mexico, trans. and ed. Anthony R. Pagden, with an introduction by J. H. Elliott (New Haven and London: Yale Univ. Press, 1986), 100–101. Pages 23, 72.

Bernal Díaz del Castillo, *The Discovery and Conquest of Mexico, 1517–1521*, trans. A. P. Maudslay and introduction by Irving A. Leonard (New York: Farrar, Straus and Cudahy, 1956), 190–91, 212–13. Pages 22, 23.

Albrecht Dürer, as quoted by Ferdinand Anders, "Las artes menores," *Artes de México* 17, no. 137 (1970): 46. My translation. Pages 15, 72.

Thomas Gage, *Thomas Gage's Travels in the New World*, ed. J. Eric S. Thompson (Norman: Univ. of Oklahoma Press, 1985), 72–73. Page 73.

Bartolomé de Las Casas, *Los indios de México y Nueva España: Antología*, ed. Edmundo O'Gorman and Jorge Alberto Manrique (Mexico City: Porrua, 1966), 25. Page 25.

Motolinía (Fray Toribio de Benavente), *Motolinía's History of the Indians of New Spain*, trans. and annotated by Francis Borgia Steck (Washington, DC: Academy of American Franciscan History, 1951), 299–300. Pages 15, 73.

Further Reading in English:

Bailey, Gauvin Alexander. *Art of Colonial Latin America*. London: Phaidon, 2005.

Donahue-Wallace, Kelly. *Art and Architecture of Viceregal Latin America, 1521–1821*. Albuquerque: University of New Mexico, 2008.

Pierce, Donna, Clara Bargellini, and Rogelio Ruiz Gomar. *Painting a New World: Mexican Art and Life, 1521–1821*. Denver: Denver Art Museum, 2004.

Pierce, Donna, and Marta Weigle, eds. *Spanish New Mexico: The Spanish Colonial Arts Society Collection*. Santa Fe: Museum of New Mexico, 1996.

Rishel, Joseph, and Suzanne Stratton-Pruitt, eds. *The Arts in Latin America, 1492–1820*, exh. cat. Philadelphia: Philadelphia Museum of Art, 2006.

Stratton-Pruitt, Suzanne L. *The Virgin, Saints, and Angels: South American Paintings 1600–1825 from the Thoma Collection*. Stanford, CA: Cantor Center, 2006.